Columbus
Indiana

IN VINTAGE POSTCARDS

To MY DAD
AND MY HERO,

KEVIN
12/08

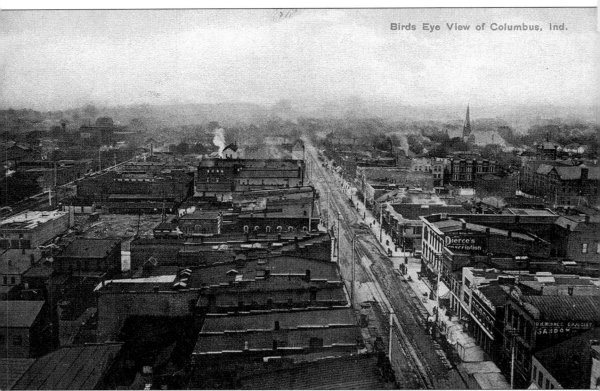

BIRDSEYE VIEW. This card shows the view looking north from high up in the courthouse. The old city hall and First Presbyterian Church are visible in the distance on the right, and the old Cerealine Mill building is visible in the top left of the card. Washington Street appears to be unpaved with streetcar tracks running down the middle, suggesting the view depicted may be slightly older than the card's postmark of 1910.

(cover) **WASHINGTON STREET.** This *c.*1940 scene shows a bustling Washington Street looking south from Third Street.

POSTCARD HISTORY SERIES

Columbus
Indiana
IN VINTAGE POSTCARDS

Tamara Stone Iorio

ARCADIA

Copyright ©2005 by Tamara Stone Iorio
ISBN 0-7385-3449-8

Published by Arcadia Publishing
Charleston SC, Chicago IL, Portsmouth NH, San Francisco CA

Printed in Great Britain

Library of Congress Catalog Card Number: 2005925678

For all general information contact Arcadia Publishing at:
Telephone 843-853-2070
Fax 843-853-0044
E-mail sales@arcadiapublishing.com
For customer service and orders:
Toll-Free 1-888-313-2665

Visit us on the internet at http://www.arcadiapublishing.com

To Chris, who is my love and support.

To Julia, Colvin, and Lukas, who are my joy and inspiration.

CONTENTS

ACKNOWLEDGMENTS

This book would not have been possible without the help of many people. At the Bartholomew County Historical Society, Michelle Bottorff and Sandy Greenlee allowed me unlimited access to their historical collections, including their vast array of postcards. I also luckily became acquainted with David Yount, an avid collector with an impressive collection of Columbus memorabilia. He generously allowed me access to his fabulous postcard collection as well. Mixing cards from my own collection with cards from the historical society and from Mr. Yount has made the book much richer and more interesting.

Thanks also to David Sechrest, who operates a website detailing the history of Columbus (www.historiccolumbusindiana.org). He shared his extensive knowledge of the area and helped find answers to my questions when he did not know them himself.

I also would like to thank three special teachers from Columbus who nurtured and encouraged my interest in writing at various stages of my education—Janice Montgomery, Faith Freeman, and Shirley Lyster. These wonderful women impacted me and countless other students over the years well beyond the classroom.

Thanks as well to Gregg Galbraith for allowing me to use photographic cards from his father, Bud Galbraith. The following images are from Bud Galbraith: pages 66a, 66b, 125a, and 125b.

Lastly, I must thank my family for supporting me through hours of collecting, researching, and writing. I thank you for the opportunity to merge my love of postcard collecting and my love of writing into this special book.

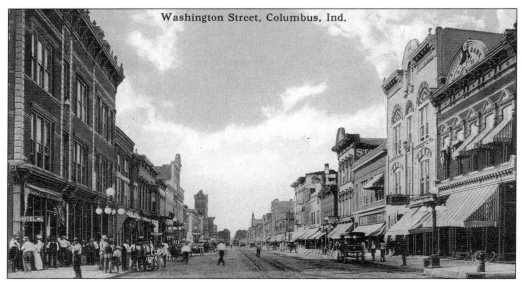

WASHINGTON STREET. This unused *c.* 1910 cards shows Washington Street north from Third Street.

INTRODUCTION

Columbus, Indiana, is a wonderful example of a small town with a big reputation. This reputation stems from its status today as a center for modern architecture. The story of Columbus begins, however, very quietly.

Columbus was founded in 1821 in south-central Indiana, where the Driftwood and Flatrock Rivers join together to form the East Fork of the White River. Its location near the river was especially important until the first train came to Columbus in 1844. Columbus remained primarily an agricultural region until the late 19th century, when a variety of local industries turned the town into a thriving manufacturing center. Some examples of early industry in Columbus included the largest tannery in the world, a manufacturer of fine furniture, the mill that produced the first dry breakfast cereal in the country, and a company that produced agricultural and automotive implements sold all over the world. Many of these early companies no longer exist, but the town survived because old industry was replaced with new industry. The founding of Cummins Engine Company (now Cummins, Inc.) in 1919 and Arvin Industries (now ArvinMeritor) in 1925 signalled the beginning of a major economic turnaround in Columbus that would shape the town through the next several decades. At the end of the 20th century, Columbus was home to the headquarters of three Fortune 500 companies.

Many of Columbus' significant buildings were built near the end of the 19th century, including the old city hall and many churches and schools. Ironically, the first architect to have a major impact on the town was from right near Columbus. Charles Sparrell lived near Hope, Indiana, and designed several prominent Columbus buildings, including the old city hall. A parade of well-known architects into Columbus would begin when modern architecture came to town in 1942 with the construction of First Christian Church. Shortly thereafter, a program was started in the 1950s by some forward-thinking Columbus citizens based on the idea that a quality community depends on the built environment within it. Initially, the Cummins Foundation agreed to pay the architect fees for any school building whose architect was chosen from an approved list of renowned architects. The program was a resounding success and was later expanded to include other non-educational buildings. Over the years, the list of buildings in Columbus designed by world famous architects has grown immensely, and in 1991, the American Institute of Architects ranked Columbus sixth—after only Chicago, New York, Washington, San Francisco, and Boston—in the entire United States for architectural innovation.

This collection of Columbus postcards is made up primarily of cards from 1900 to 1950, with a final chapter of newer cards that highlight modern architecture. Since the late 19th century, postcards have been a popular means of communication throughout the United States. Fortunately, postcards were not limited to big cities or tourist destinations, and small towns were also the source of numerous cards. Vintage postcards offer us a brief glimpse into the roots of Columbus through its buildings and people, and viewing some of the original beautiful architecture in Columbus helps place its newer structures into historical perspective.

INTRODUCTION TO POSTCARDS

By the 1870s, picture postcards were becoming commonplace in Europe, but were not yet common in the United States. Since the early 1900s, postcards have been very popular in the U.S. as well. Because the number of surviving vintage postcards is so high, knowing something about the history of postcards helps the viewer learn more about the history of the cards' subjects. There are several identifiable eras of postcards that help date a postcard.

Pioneer Era (1870–1898). The first cards that were printed and intended to be souvenirs came from the Columbian Exposition in Chicago in 1893. All cards that were privately printed during this time required a two-cent stamp, while all government cards required a one-cent stamp. Few of these cards remain.

Private Mailing Card Era (1898–1901). Between 1898 and 1901, American companies were allowed to sell private cards which were imprinted with the words "Private Mailing Card" on the back and which only required a one-cent stamp. The backs of these cards were reserved for addresses, and any messages had to be written on the fronts of the cards.

Undivided Back Era (1901–1907). After December 1901, the government allowed publishers to use the word "Postcard" or "Post Card" on the back of privately-printed cards. Messages still could be written only on the front of the card, and because of this, these cards do not lose any value if there is writing on the front.

Divided Back Era/Golden Era (1907–1915). In March 1907, the government finally allowed the printing of cards with a divided back, with the address on the right and the message on the left. Most postcards were printed in Germany, where the printing process was very advanced. Accordingly, many beautiful view cards came from this period, and collecting became quite popular.

White Border Era (1915–1930). In the time leading up to World War I, the flow of cards from Germany slowed and the overall supply of postcards diminished. Cards printed during this era usually had a white border around the edge, which required less ink and made them less costly to print.

Linen Era (1930–1945). During this time, postcards were printed with a new process, which allowed a high rag content and gave the cards a textured feel and the look of linen. These cards, which were very colorful, were cheap to produce and were very plentiful.

Photochrome Era (1939–Present). High quality photographic image cards have been the most common type of cards for over 60 years now.

One
GREETINGS

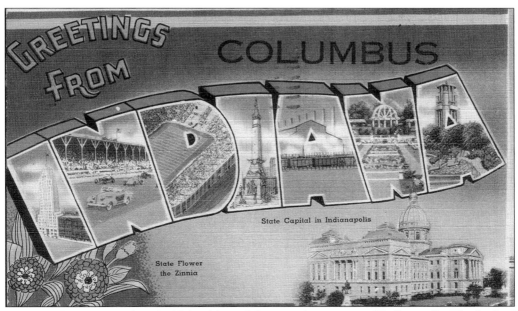

INDIANA GREETINGS. Sent in 1946, this card shows various scenes of Indianapolis. The back of the card includes this information: "Nickname—Hoosier State; 1940 Population—3,427,796; Area in Square Miles—36,354; Entered the Union—December 11, 1816." The sender is interested in postcard collecting and writes, "I would like to exchange view cards with you. Would you care to trade 3 or 5 cards at a time?"

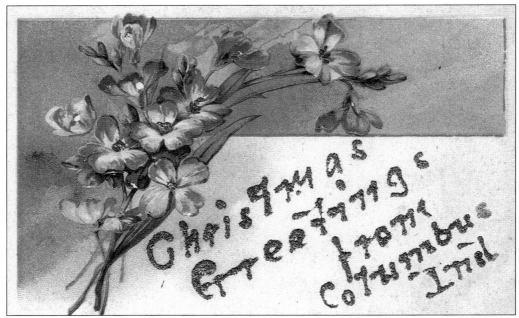

CHRISTMAS GREETINGS. This card was a standard floral postcard to which the sender added glue and silver glitter to personalize it and transform it into a holiday greeting. It was sent in 1907 from Columbus to Lebanon, Indiana. The sender writes, "Mother is much worse. She came very near having pneumonia. We have our Xmas exercises tonight. Revival begins next Sun."

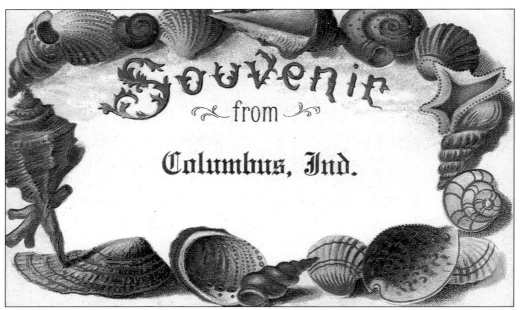

SOUVENIR CARD. Although this card may have been a souvenir from Columbus when it was sent to Indianapolis in 1910, the gold seashells depicted on the front are clearly *not* souvenirs from land-locked Columbus. The cryptic message says, "Sis: Hope you are all o.k. now. We are just kicking that is all. I am still home sick some of these days. I am going to pull freight don't you tell."

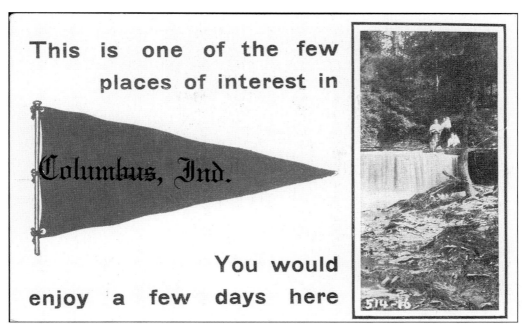

PLACES OF INTEREST. The postmark is not legible on this *c.* 1910 card that was sent to Fort Wayne, Indiana. The waterfall in the picture is not identified, but may be what is now known as Anderson Falls in eastern Bartholomew County. The writer asks, "Is it as hot up there as it is here? This day has been a scorcher."

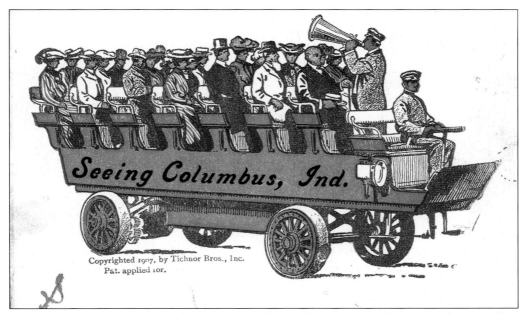

SEEING COLUMBUS. This colorful unsent card shows what appears to be a tourist bus complete with tour guide in front. The card unfolds to measure approximately 3 inches by 10 inches when opened. Glued inside is a long accordion sheet with a row of tiny views of Columbus, all of which themselves can be found on other postcards of the time.

Greetings from Columbus, Ind.

STANDARD VIEW CARDS. These unused, divided back postcards are examples of greeting cards that carried standard views or generic views. Postcard publishers printed cards with various outdoor scenes and then put different city names on the cards. Sometimes only natives of the area could recognize the view was not authentic. Sometimes it was more obvious, for example if the name of a town whose terrain was very flat was printed on a picture of a hilly landscape. These 1920s–1930s era cards are good examples of this, as no such large lakes lie near Columbus.

Greetings From Columbus, Indiana

Greetings from COLUMBUS, INDIANA

STANDARD VIEW LINEN. This is a slightly later card that is very similar to the previous ones. The colorful linen view was postmarked in 1945 from Columbus to Iowa. This card again shows a lakeside road scene that does not appear to be from Columbus.

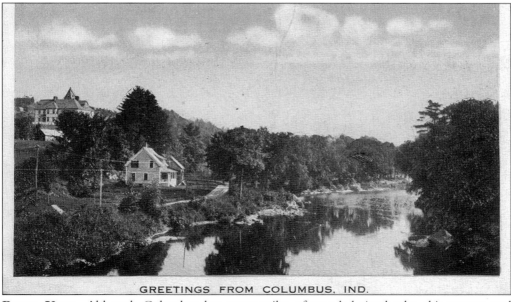

GREETINGS FROM COLUMBUS, IND.

RIVER VIEW. Although Columbus has many miles of wooded riverbanks, this unsent card appears to be another card with a standard image that was not taken from Columbus, as nowhere along the river were there large homes such as the two pictured here. The card is *c.*1920s–1930s.

HURRY BACK CARD. Postmarked October 9, 1913, from Lula to Mrs. Lily Merritt, the message reads, "Lily if you can come up Saturday bring that collar of yours as Mrs. Brown wants to see it. She is going to make Edna one and send it to Detroit for her. They are all crazy about that collar since I told them about it." The same sender continued her message to Mrs. Merritt on the next card.

HALLOWEEN CARD. Also sent to Mrs. Lily Merritt, on October 15, 1913, Lula writes, "I suppose you got Mrs. Brown's collar. I am going to make me one some day. . . . Is there any hickory nut out there. If there is mabe (sic) Edna and I can come out and get some." This Halloween card was not printed with the city name, which was added later.

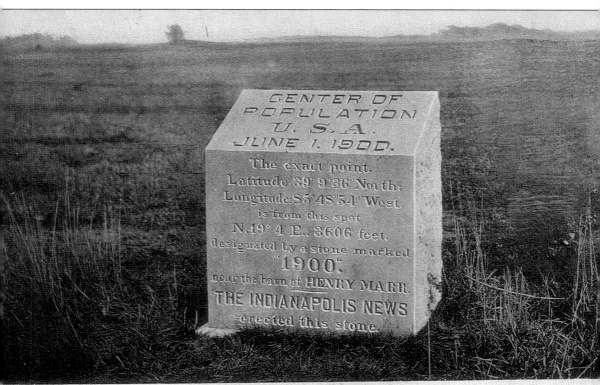

Center of Population, Columbus, Ind.

POPULATION MARKER. This card was postmarked September 1909, and highlights an interesting fact about Columbus. Every ten years, after the census, the federal government has tracked the mean center of population of the United States. As would be expected, this point has moved gradually west since 1790, when it was located in Maryland. After the 1900 census, the exact center of the United States population was located in Rockcreek Township in Columbus near Henry Marr's barn, as described on the inscription on this stone marker. From writings of the time, this seemed to be a source of pride for citizens of Columbus. By the next census in 1910, this point had moved approximately 40 miles west into Monroe County, and in 1914, a book about Columbus advertises it as only "forty miles from the center of population of the United States." The population center was located in Indiana from the time of the 1890 census until the 1940 census. By the year 2000, the mean center of population had moved into the middle of Missouri.

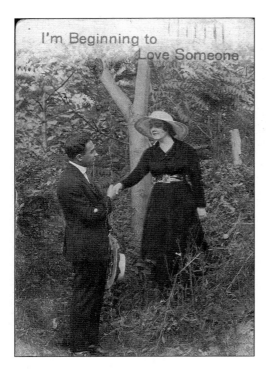

BEGINNING TO LOVE. On April 5, 1919, this lovely and brightly-colored romantic card was sent from Columbus to Mr. Clarence Graffa in Corning, Kansas, with a thoroughly unromantic message—"We are having a fine time in Columbus, wish you were here sure. Going to the shows now but I haven't any fever. ho. ho."

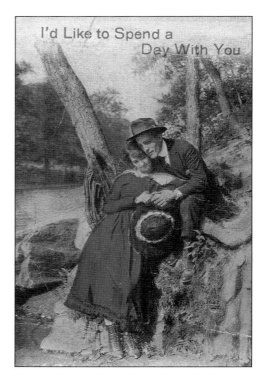

ROMANTIC CARD. On March 3, 1919, a different sender mailed a similar romantic card to the same Clarence Graffa in Corning, Kansas. "Will drop you a card to let you know that I am all o.k. and hope the same of you. Say Clarence how do you like the card I am sending you?" This card was also colored with bright reds and blues.

GREETINGS FROM COLUMBUS, IND.

GREETINGS FROM COLUMBUS. This card most likely shows a standard view not from Columbus. Although Columbus has many miles of wooded riverbanks along the Flatrock, Driftwood, and White Rivers, the hills shown in this scene appear higher than what is typical around Columbus. The card is unsent and *c.* 1910.

Greetings From Columbus, Ind.

BLUE FLOWERS. This lovely card was sent in April 1909, to Riverton, Illinois. The sender evidently worked building or maintaining roads, as the message reads, "Hello, having a fine time, like the place, been so busy, have not had time to get lonesome yet. Tell Mr. S. that we've lost are (sic) job, the roads are gravel, therefore they are independent and don't need are (sic) sinders but if I find any other polished job will let him know."

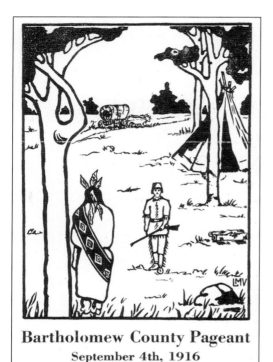

Bartholomew County Pageant
September 4th, 1916

BARTHOLOMEW COUNTY PAGEANT. Typed on the back on this unused card is the following information: "The picture on the reverse of this card designed by Miss Lillian M. Volland, represents the Indian and the fur trader and pioneer coming into the wilderness. The PAGEANT will present in a series of dramatic episodes, the story of the development of Bartholomew County from that time to the present.—September 4, 1916, Columbus, Indiana."

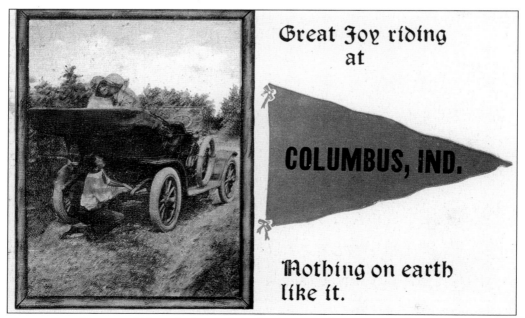

Great Joy riding at

COLUMBUS, IND.

Nothing on earth like it.

GREAT JOY RIDING. Although the card depicts a man who is apparently repairing an early automobile, the passengers seem oblivious to this, and the message suggests riding in an automobile in Columbus is quite enjoyable. This card was sent from Columbus to Haughville, Indiana, on August 18, 1915.

Two
COURTHOUSE & STREET SCENES

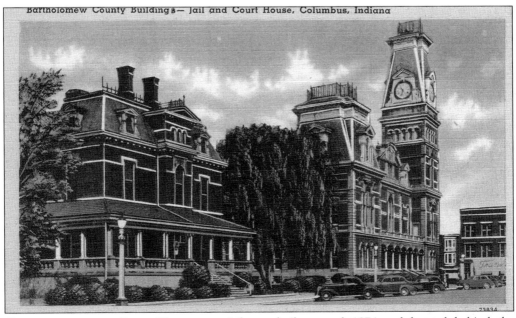

Bartholomew County Buildings— Jail and Court House, Columbus, Indiana

COURTHOUSE AND JAIL. The county jail was built around 1874 and located behind the courthouse. The sheriff's headquarters and living quarters for his family were also in this building, which was torn down in 1966. The message reads, "We had a room here for 1.00 each. Was nice and hot. Sure can notice the accent these folk have, took walk over to corner drugstore then on to Greek ice cream parlor. . . . Next day we were taken through that Christ Church, oh what a place."

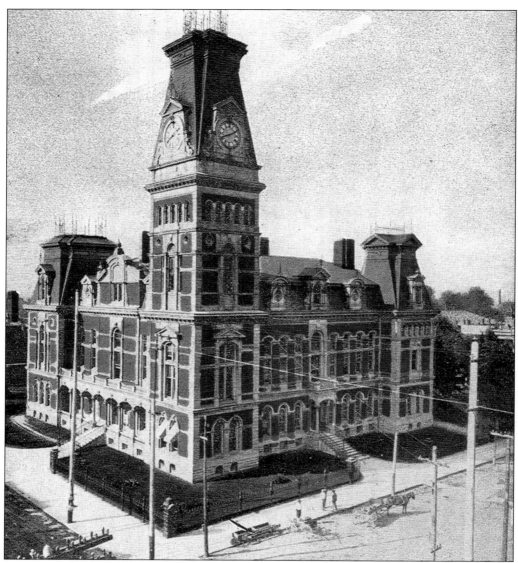

COURTHOUSE. Dedicated in 1874 after three years of construction, the Bartholomew County Courthouse was designed by Isaac Hodgson and built by McCormack and Sweeney. The cost was $250,000, which was thought to be a large amount at the time. Upon completion in 1874, the courthouse was labeled "the finest in the West." A large celebration with speeches and music and dancing commemorated the dedication. The courthouse clock was installed in 1875 in the 154-foot-high clock tower. The clock bell was six inches thick and weighed around 10 tons. Well into the 20th century, the courthouse clock continued to run with its original clock mechanisms. In 1940, the clock's weighted mechanisms were replaced with an electric motor after a cable support broke and a 900-pound weight fell within the clock tower. The courthouse has been updated and remodeled many times over the years, but except for some minor changes—including the removal of the dormers in the roof—the exterior of the courthouse appears today much the same as it did in the late 1800s. This card was sent from Columbus to Owenton, Kentucky, in April 1909, and the sender writes simply, "You are not forgotten."

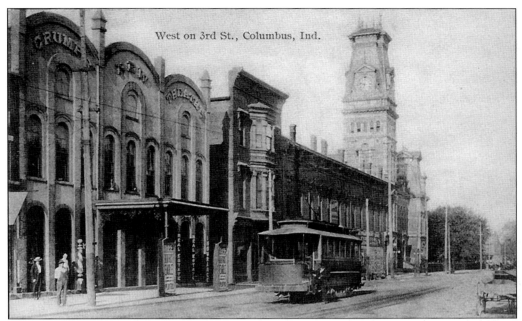

West on 3rd St., Columbus, Ind.

THIRD STREET AND COURTHOUSE. This *c.* 1910 card shows Third Street looking toward the courthouse with Crump's New Theatre visible on the left. The theater opened in 1889 and still stands today. John Crump, who built the theater, also started Columbus' first streetcar system in 1890, and one of the trolley cars can be seen in this view.

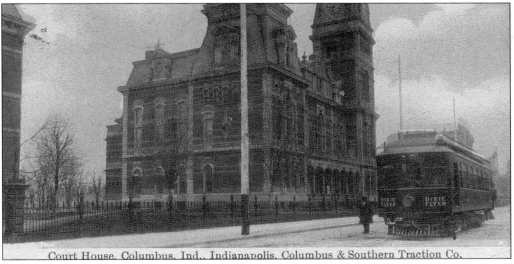

Court House, Columbus, Ind., Indianapolis, Columbus & Southern Traction Co.

COURTHOUSE AND INTERURBAN TRAIN. On July 25, 1890, *The Evening Republican* reported, "The street railroad will be graded today as far as Washington and Eleventh streets. The ties are being placed in the excavation as rapidly as it is made. The rails will be placed in the track by the middle of next week, then the line will be ready for the cars. . . ." Electric streetcars that ran between cities were called "interurbans" and had many advantages over steam trains. Because interurbans ran on electricity, they were cheaper and more efficient, and thus ticket prices were lower and trains ran more often.

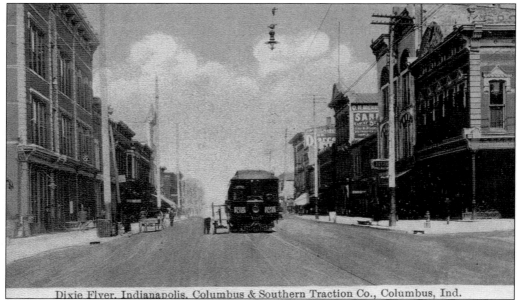

Dixie Flyer, Indianapolis, Columbus & Southern Traction Co., Columbus, Ind.

DIXIE FLYER. The Dixie Flyer was the southbound interurban train traveling from Indianapolis to Louisville, Kentucky, and started service in 1908. This view shows the card stopped at the interurban station at Third and Washington, loading or unloading. Because interurbans came into town on existing streetcar tracks, they conveniently carried people directly into the downtowns of many cities, instead of stopping at train stations that were sometimes several blocks away at the edge of town. This card is unused and *c.* 1910.

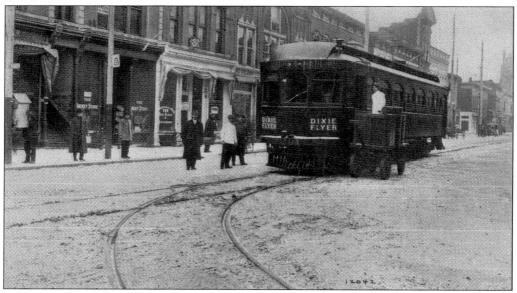

DIXIE FLYER. This close-up real photo card again shows the Dixie Flyer at Washington and Third, where the streetcar tracks curved onto Third Street. In this view, a cart is loading or unloading on the right side of the train. By 1914, 47 cars passed through Columbus each day on the electric trolley lines. This card was not sent and is *c.* 1910.

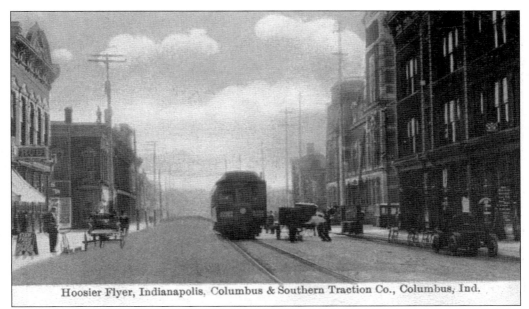

Hoosier Flyer, Indianapolis, Columbus & Southern Traction Co., Columbus, Ind.

HOOSIER FLYER. This picture shows the Hoosier Flyer with the courthouse visible just behind the train on the right. The Hoosier Flyer was the northbound interurban traveling from Louisville to Indianapolis. The train also appears to be stopped at the interurban station at Washington and Third. This card was not sent and is *c.* 1907–1915. After 1910, the popularity of electric streetcars began to wane with the increased prevalence of the automobile.

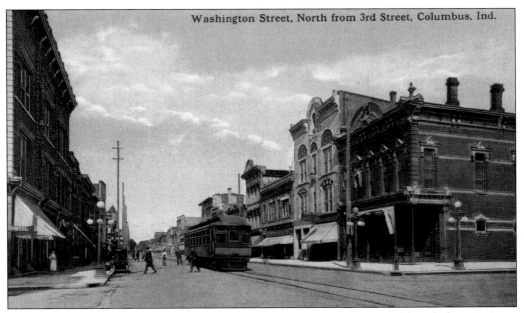

Washington Street, North from 3rd Street, Columbus, Ind.

STREETCAR. This card shows another view of a trolley car on Washington, although the train is not identifiable. After the Public Utility Holding Act was passed in 1935, train companies were no longer allowed also to own power companies, and interurban operators no longer had access to cheap sources of power, further leading to their decline. The last interurban line in Indiana closed in 1941.

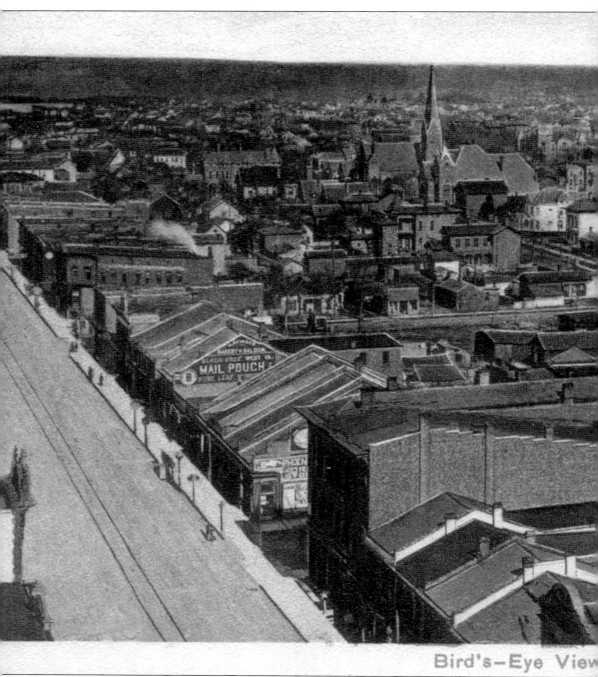

Bird's-Eye View

EARLY BIRDSEYE VIEW. This unused card shows the view looking northeast from the courthouse. Although the card itself is *c.* 1907–1910, the view is *c.* 1890. Most notably, city hall (which was completed in 1896) is absent from this view. In addition, Railroad Square—located in the block between Fourth and Fifth Streets and between Franklin and Mechanic (later Lafayette)—was still present at this time. Later Railroad Square would become a city park and

24

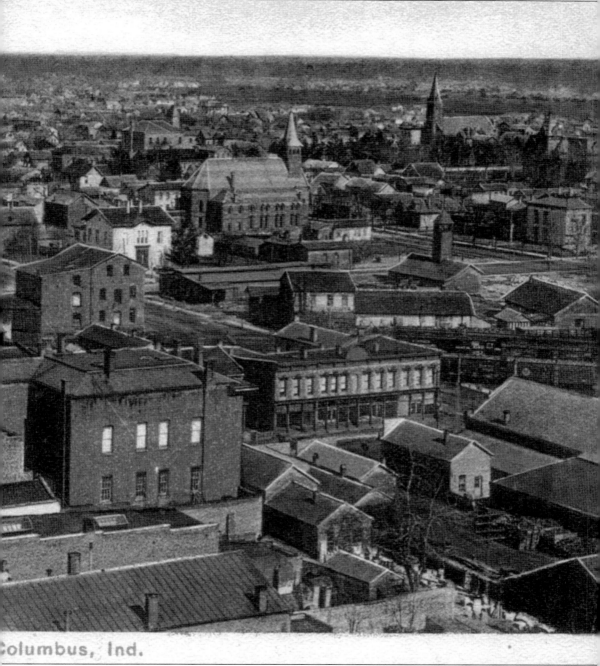

Columbus, Ind.

then eventually the home of what is today First Christian Church. The original Tabernacle Christian Church is also visible where today the library stands. Several of the buildings seen in this view still stand today, including the Irwin Home on Fifth Street (visible at the far right of the card) and the Storey Home, which would become the Columbus Visitors Center. The spires of the First Presbyterian Church and St. Bartholomew Catholic Church rise in the distance.

25

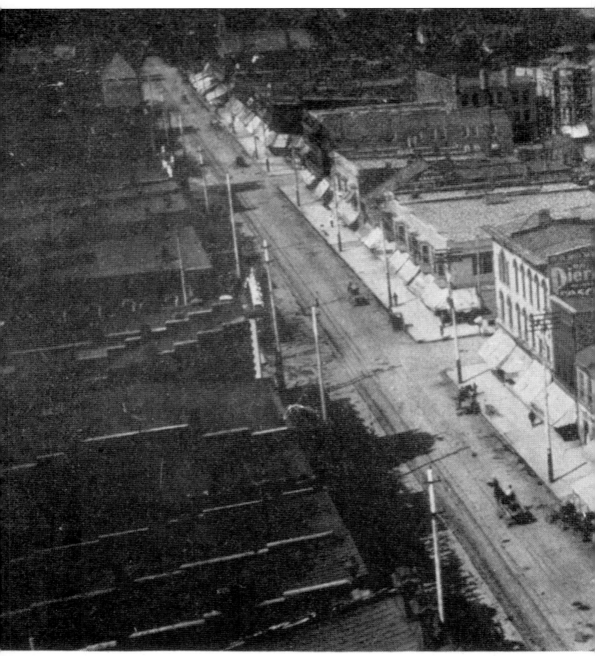

Birdseye View Wash. St.

LATER BIRDSEYE VIEW. Although this card was postmarked 1909, the view on the front is much later than that of the previous pages. Again looking northeast from the courthouse, old city hall is now visible on Fifth Street, and while not as easily seen, the downtown fire station is just to the left of city hall. At the corner of Fifth and Mechanic (later Lafayette), the library now sits

om C. H. Columbus, Ind.

next to the Tabernacle and is visible in the upper right corner of the card. Directly across Fifth Street, the former Railroad Square has been transformed into a city park. In addition, several of the buildings on Washington Street have taken on a more recognizable shape, and horse-drawn carriages are visible on the street.

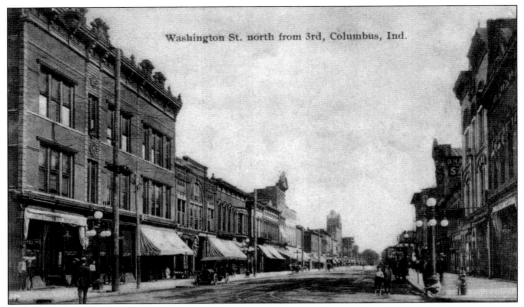

NORTH ON WASHINGTON, 1913. This real photo card was sent in 1913 from Columbus to Indianapolis. Taken from Third and Washington in front of the courthouse, this card shows the interurban station as the first building on the left, and its sign is visible with a magnifier. This entire block on the west side of Washington between Third and Fourth was cleared in the 1970s for the construction of an urban mall.

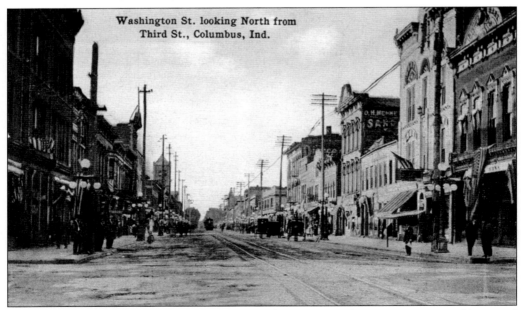

Washington St. looking North from
Third St., Columbus, Ind.

NORTH ON WASHINGTON, 1916. Numerous flags are now hanging as a sign of increased patriotism during World War I. Sent from Columbus to Dayton, Ohio, in July 1916, the sender writes, "Dear Alta, we motored over to this town today and are now sitting in the shade trying to keep cool. Got jiggers the other day in the blackberry patch. Ever had any?"

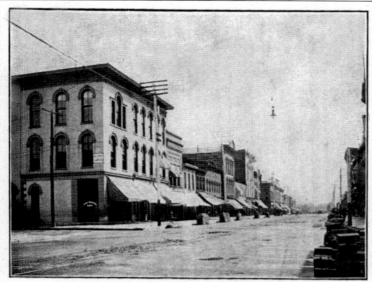

Looking South on Washington St., Columbus, Ind.

GEO. H. CUMMINS, BOOKSELLER

SOUTH ON WASHINGTON, PRE-1907. This unused card is an undivided back card that is pre-1907. Had the card been sent, the message would have been written on the front side with the picture. The view is looking south on Washington from Fourth Street. At the side of the street, stacks of bricks can be seen, presumably ready for paving. The card was published by George Cummins, who owned a bookstore in Columbus from 1892 until his death in 1948.

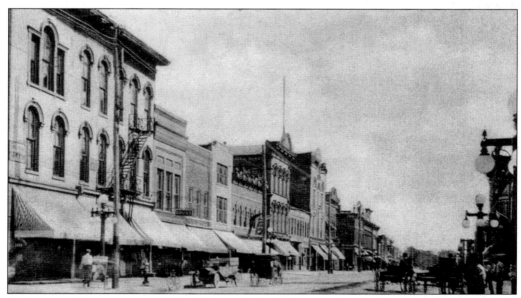

SOUTH ON WASHINGTON, 1912. This card shows the view from Fourth Street looking south as well, although it is several years later. Both carriages and automobiles are present on the street, and the ornate streetlights are visible as well. A drugstore sign is present on the left above an awning. This real photo card was sent in 1912.

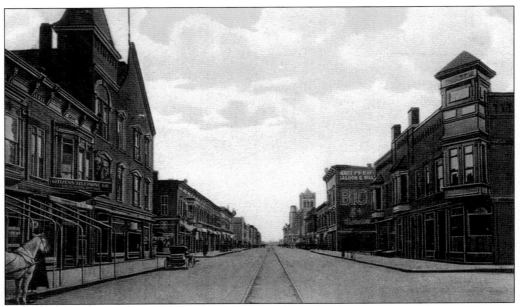

WASHINGTON SOUTH FROM SEVENTH, C. 1907–1910. This illustrated view looking south on Washington shows the Citizens Telephone Company on the left. Citizens Telephone Company was incorporated in 1895 and stood at 607 1/2 Washington. The Matt Pfeifer Saloon & Billiards is down a block on the right at 528 Washington. Streetlights and utility poles are not yet present. The card is unsent *c.* 1907–1910.

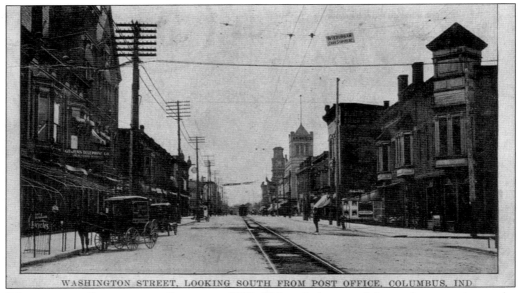

WASHINGTON STREET, LOOKING SOUTH FROM POST OFFICE, COLUMBUS, IND.

WASHINGTON SOUTH FROM SEVENTH, 1912. This real photo card shows the same view as the previous card, but was postmarked to Indianapolis in 1912. The first building on the right was the city post office at the time. An even earlier post office had been located at 406 Washington, which was the eventual home of the Cummins bookstore. Visible here are the electric trolley cables and a sign above the intersection that says, "Interurban cars stop here."

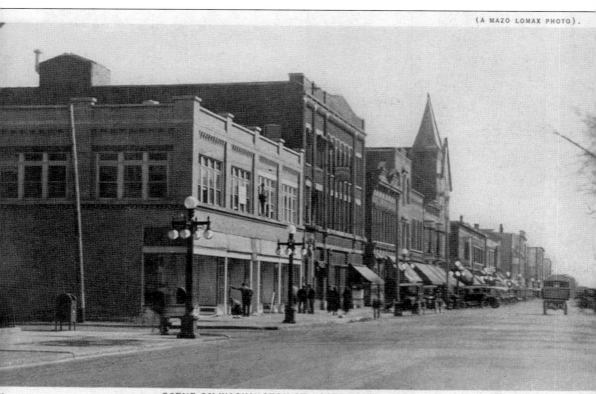

SCENE ON WASHINGTON ST., COLUMBUS, IND.

WASHINGTON SOUTH FROM SEVENTH, POST-1915. This real photo view was made from a vantage point just slightly north of the two previous cards looking south towards the east side of Washington Street. Although it is unused, judging by the early automobiles now present on Washington Street and the addition of the ornate streetlights, this view was made several years after the previous one. Additionally, the card is a white border card, which dates from between 1915 and 1930. A mailbox is present on the street corner on the left, and sometime between 1912 and 1916, the post office had relocated to the northeast corner of Seventh and Washington. The building on the left with the pointed tower is the Oddfellows Building at 605 Washington. Constructed in 1893, the building has had many uses over the years, and the letters "I.O.O.F." are still visible on it's façade.

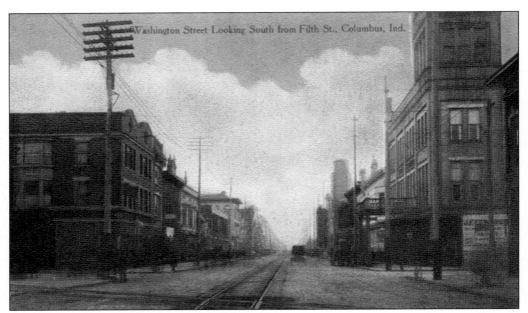

WASHINGTON SOUTH FROM FIFTH, 1909. This card was sent to Hettinger, North Dakota, in September 1909. The sender writes to her daughter far away, "Dearie—Your letter rec'd today. We are all well. I send this to assure you that Wagners will not visit you this fall or winter. Carrie said she could not think of taking such a long trip. Do not think of it again. Make all the plans you want to. Wagners won't interfere. Will write soon. Your Mother."

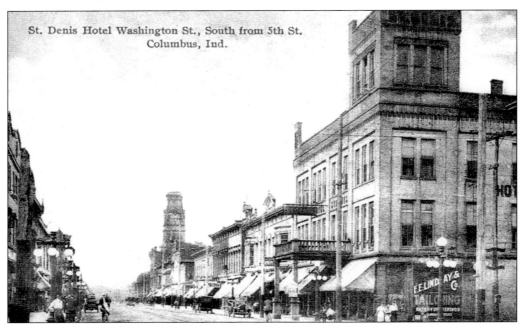

WASHINGTON SOUTH FROM FIFTH, C. 1920. This real photo card shows the view looking toward the courthouse with the St. Denis hotel located on the right with the tower. The St. Denis was one of several hotels in Columbus at the time and was thought to be one of the nicest as well.

Washington St. North from 5th St., Columbus, Ind.

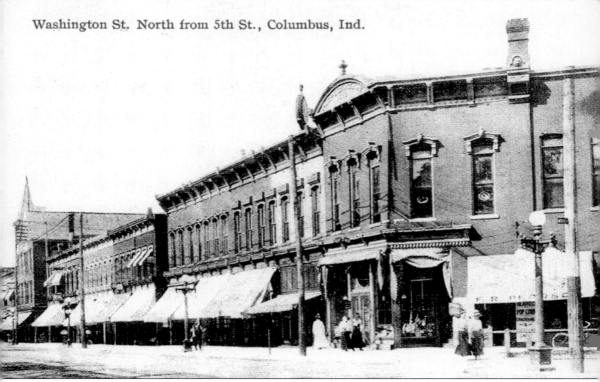

WASHINGTON NORTH FROM FIFTH. This real photo view of Washington was sent from North Vernon, Indiana, to Meade, Kansas, May 16, 1915. The sender writes, "Dear Aunt, We took a auto drive to Columbus, Ind. this afternoon. . . . Fine roads after some rain." The large building visible on the corner of Fifth was the home of a local newspaper, *The Evening Republican*, which was founded in November 1877. In the late 19th century, it was one of four daily papers in Columbus. The unusual angle of the building at the corner of the intersection reflects the fact that early on, the train trains ran diagonally across the intersection at that spot towards Railroad Square farther down on Fifth Street. This building is gone now, and today, the Home Federal Bank stands in its place.

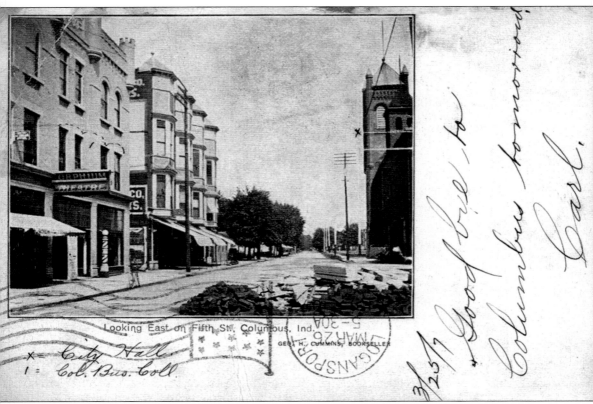

Looking East on Fifth St., Columbus, Ind.

GEO. H. CUMMINS, BOOKSELLER

x = City Hall.
1 = Col. Bus. Coll.

3/25/7 Good bye to
Columbus tomorrow.
Carl.

EAST ON FIFTH STREET. This early real photo card was postmarked March 1907, from Columbus to Logansport, Indiana. The view is taken from Washington Street looking east on Fifth Street. It appears the road is in the process of being paved with stacks of stones or bricks visible on the street. On the left, the Orpheum Theatre can be seen. This later became the American Theater and then the Rio. Vaudeville shows, traveling shows of different types, and eventually moving pictures were all enjoyed here. This building was also known as the K of P Building, and today a parking lot stands in its place. The sender has used an "x" to mark the location of city hall, and the fire station tower is just visible next door. At the bottom of the card the writer suggests he has used "1" to mark Columbus Business College, but this mark is not visible on the picture itself.

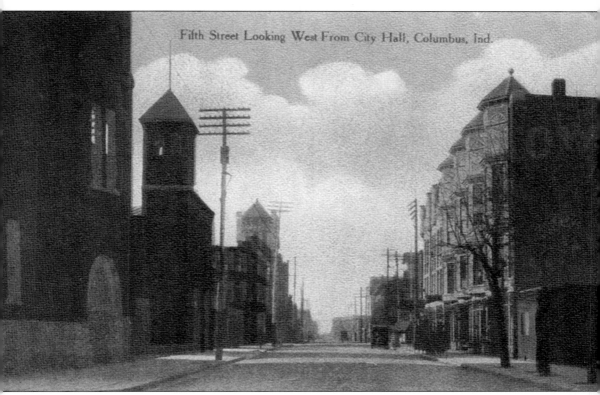

Fifth Street Looking West From City Hall, Columbus, Ind.

WEST ON FIFTH STREET. This view was taken looking west from the other end of the same block pictured on the previous card. The lower part of old city hall is immediately on the left with the tower of Fire Station Number One obvious just past it on the left. In the distance, the tower of the St. Denis Hotel tower is visible at Fifth and Washington. The K of P Building, which contained the Orpheum Theatre, is the second building on the right. The first building on the right with the lovely architectural features around the windows was known as the Irwin Block. Both old city hall and the Irwin Block still stand today, while the fire station and the K of P Building are gone. The card was sent from Hartsville, Indiana, to Barrallton, Kentucky, in March 1913. Complaining about either Hartsville or Columbus, the sender writes, "Should like to see all of you this evening as it is rather dull here."

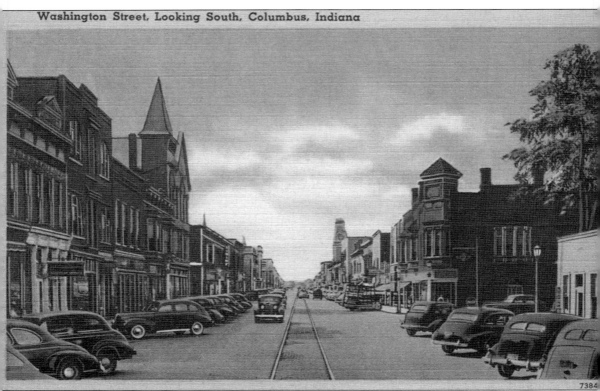

WASHINGTON STREET IN DAYTIME. This linen card shows a bustling Washington Street looking south from Seventh Street. Traffic is two-way and would remain this way on Washington until the 1970s, when it was changed to one-way going south. In the 1990s, Washington again returned to two-way traffic. This card was unused, but the era of linen cards lasted from 1930 to around 1945. The streetcar tracks, which were removed sometime in the early 1940s, were still visible when this view was made. Standing at this point today, the view of the buildings is largely the same, without the vintage automobiles.

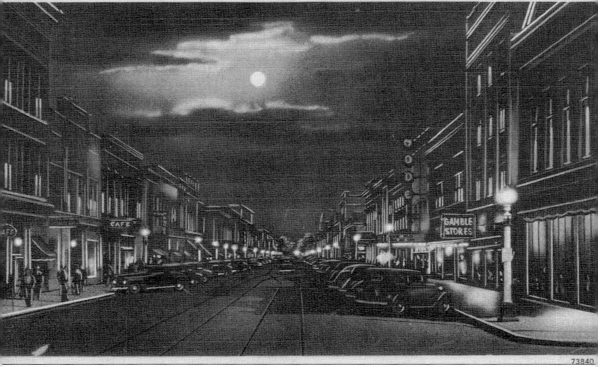

73840

WASHINGTON STREET AT NIGHT. This view looks north from Third Street. Many businesses of the time are identifiable, including Gamble Stores, which sold furniture, automobile accessories, and sporting goods. The card is not dated, but Gamble Stores is first listed in the Columbus City Directory in 1942. Also visible are the Mode Theater and several cafés on the left. The city directory from 1942 lists three cafés in the 300 block of Washington on the east side of the street—Court House Café, Terminal Café, and Sanitary Café. Other businesses that were located in this block, but are not identifiable in this view, include J. C. Penney, Woolworth, and Zaharako's. The block of buildings on the right still stands today, but the block on the left was cleared for the construction of The Commons Mall in the 1970s. Two sets of streetcar tracks are visible in this card, compared to a single set in the previous picture. Although the tracks remain, by 1942, the interurban station was gone from the corner of Washington and Third. This card was unused.

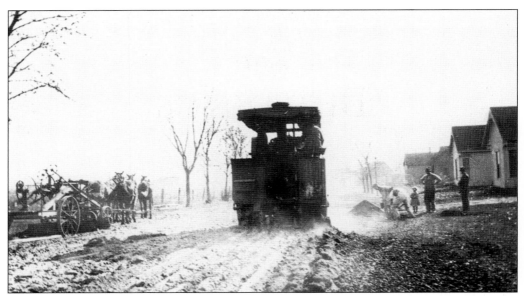

CENTRAL AVENUE. This real photo postcard is hand-labeled 1918 on the front. Pictured is the construction of a section of Central Avenue, using both horse-drawn and motorized machinery. At the time, this was outside the main part of the city, but Central is today one of the busiest streets in Columbus. The card is unsent.

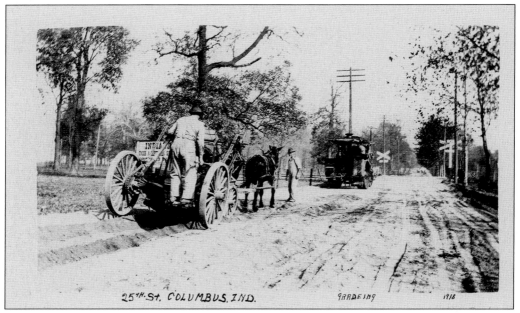

TWENTY-FIFTH STREET. Another real photo card labeled 1918, this view shows the "gradeing" of Twenty-fifth Street, as labeled on the front. This area also was considered very rural at the time and was a significant distance from downtown. While telephone poles are already in place, empty farmland is visible along the road. Today, this is the heart of commercial Columbus.

Three
BUILDINGS

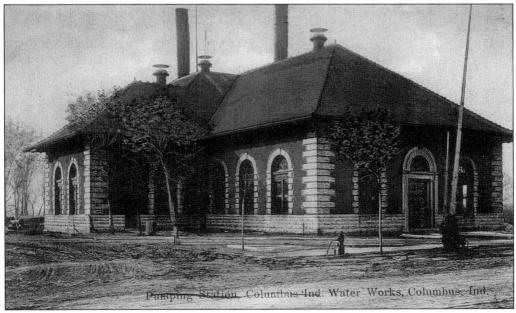

Pumping Station, Columbus Ind. Water Works, Columbus, Ind.

WATERWORKS. The city waterworks and pumping station was built between 1901 and 1903 at the west end of Second Street on the banks of the East Fork of the White River. The building was constructed to last with a stone foundation that was two feet thick and inside walls that were 17 inches thick. It was used to supply city water until the 1950s, when city water was drawn from a system of deep wells. This card was sent to Westport, Indiana, in 1915.

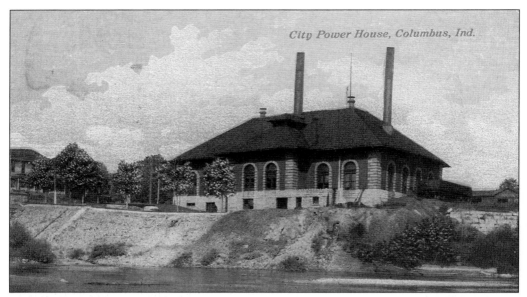

City Power House, Columbus, Ind.

CITY POWER HOUSE. Sent from Columbus to Indianapolis in May 1912, this card again shows the waterworks building, which was also known as the city power house, perched on the riverbank. The electricity produced by the plant's steam generators powered streetlights in Columbus. Initially wood, and later coal, was used to fuel the boilers needed to generate power. The building still stands today and currently houses the Senior Citizens Center of Columbus.

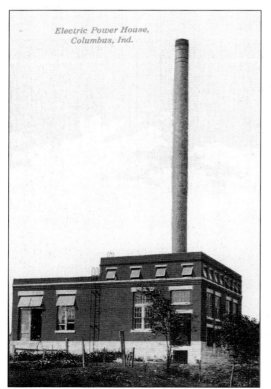

Electric Power House, Columbus, Ind.

ELECTRIC POWER HOUSE. The location of this building is unclear, although it may have been farther down the banks of the river from the city waterworks. John Crump, a prominent Columbus businessman in the late 19th century, built his own powerhouse at one time to provide electricity to his home on Lafayette (reportedly the first home in town with electricity) and to provide power to the Crump electric streetcar system he created. This powerhouse may have been the Crump powerhouse.

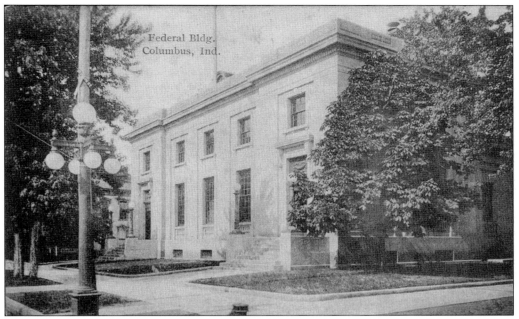

FEDERAL BUILDING. This real photo card shows the Federal Building at the northeast corner of the intersection of Seventh and Washington. This building still stands today and has been used in recent years as an administration building for the school corporation. The card was sent to Charles City, Iowa, from Columbus in 1913. The message reads, "We missed you from class lately. Try & be present Sunday. Help encourage the leaders."

POST OFFICE. This unused linen card shows the other function of the Federal Building as the Columbus Post Office. This was at least the third post office in Columbus, with the previous two locations being the eventual home of Cummins Bookstore in the 400 block of Washington and the building at the southwest corner of Seventh and Washington.

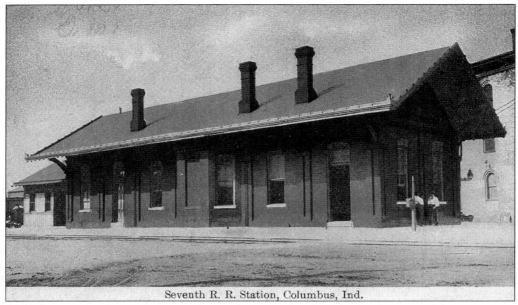

Seventh R. R. Station, Columbus, Ind.

SEVENTH RAILROAD STATION. This card was mailed from Columbus to California in May 1910. The sad message reads, "Dear Grandma, How are you standing these beautiful days. Mrs. Garber has cancer of the stomach. No hopes for her. " This railroad station stood near the Cerealine Mill, which can be seen in the background at Seventh and Jackson Streets.

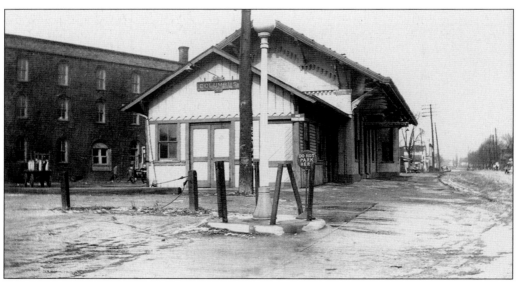

PENNSYLVANIA STATION. This unused real photo view shows the same railway station as the card above and is hand-labeled "Pennsylvania R.R. Columbus, Ind" on the back. The station was moved about a block south in the 1950s, and this building was razed. The new station was later also razed in the 1970s for the construction of the Cummins Engine Company world headquarters, while the Cerealine building in the background was incorporated into the design of the new Cummins building.

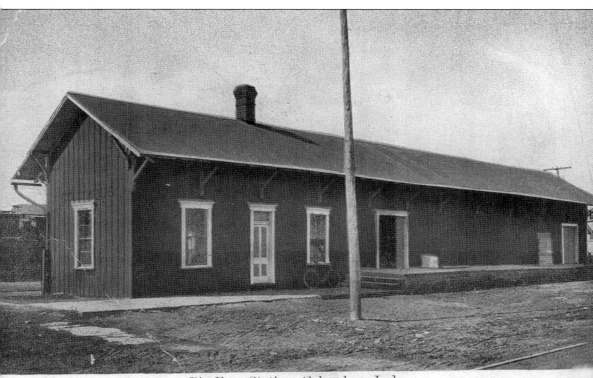

Big Four Station, Columbus, Ind.

BIG FOUR STATION. The Big Four of this card refers to the railroad company which used the station—originally the Cincinnati, Indianapolis, St. Louis & Chicago and later the Cleveland, Cincinnati, Chicago & St. Louis. This depot was apparently located in Railroad Square in the block between Franklin and Mechanic (Lafayette) and between Fourth and Fifth. This area would later be transformed into a city park and then eventually into the home of the First Christian Church. The original Railroad Square station was built in 1870, but within a few years, the railroad lines going to the Pennsylvania station and its location on Jackson Street made it more popular. The older depot was then razed, although several other buildings in the square remained abandoned for many years. Reportedly Railroad Square was considered a major eyesore and a source of unpleasant noise and pollution by its neighbors when it was in use. This unused and undated card is *c.* 1907–1914.

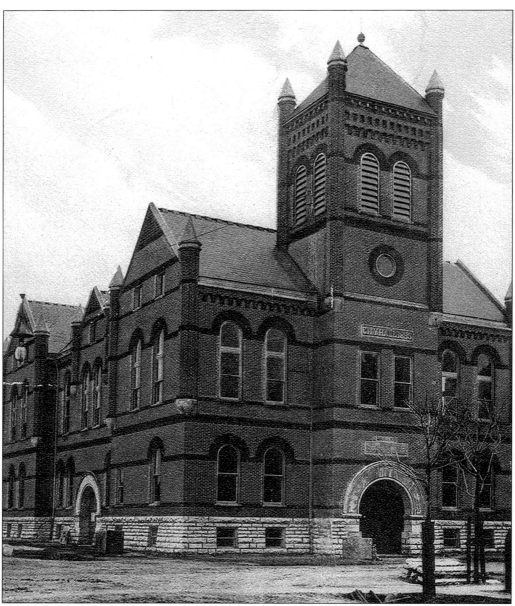

CITY HALL, 1909. City hall was built in 1895 one block off of Washington on Fifth Street. Local architect Charles Sparrell designed the building with arched windows and doorways and a distinctive square tower. Besides serving as home to city offices, the building served a variety of other uses as well. Initially the police station and jail were also located on the main floor and a farmer's market could be found in the basement. The second floor of city hall was a large auditorium and was used at various times for dances, music recitals, basketball games and other sports, and exhibitions—including a weeklong poultry show in 1908. A new city hall was constructed in the 1980s, and the older building was remodeled into a bed-and-breakfast. Old city hall is now the Columbus Inn and has been placed on the National Register of Historic Places. This card was sent in 1909 from Columbus to Shelbyville, Indiana.

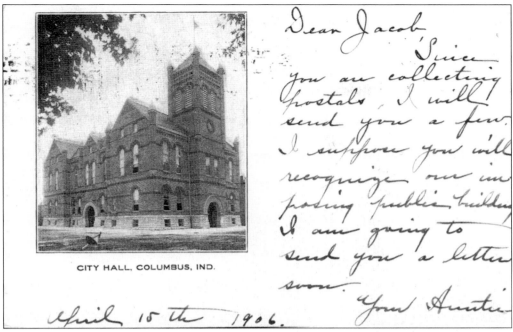

Dear Jacob,
Since you are collecting postals, I will send you a few. I suppose you will recognize our imposing public building. I am going to send you a letter soon.
Your Auntie

April 15 th 1906.

CITY HALL, COLUMBUS, IND.

CITY HALL, 1906. This early undivided back card again shows city hall and was sent in 1906 to one of America's first postcard collectors from his aunt. Part of the message reads, "Since you are collecting postals, I will send you a few. I suppose you will recognize our imposing public buildings."

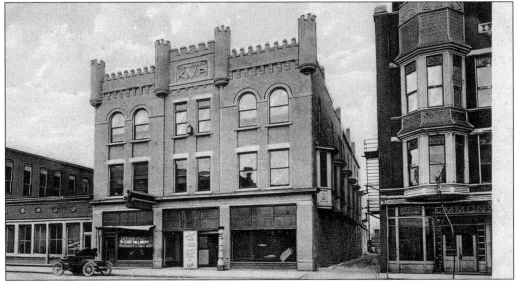

K OF P BUILDING. Located on Fifth Street across from the fire station, the Knights of Pythius was a fraternal lodge. The sender writes, "When you get big join a lodge like your papa." This building was also home to a theater—the Orpheum, then the American, then the Rio. Inside the lobby a lighted, overhead map of Hollywood landmarks was a big attraction. This card was sent in 1910 to Scipio, Indiana. A bank parking lot now sits here.

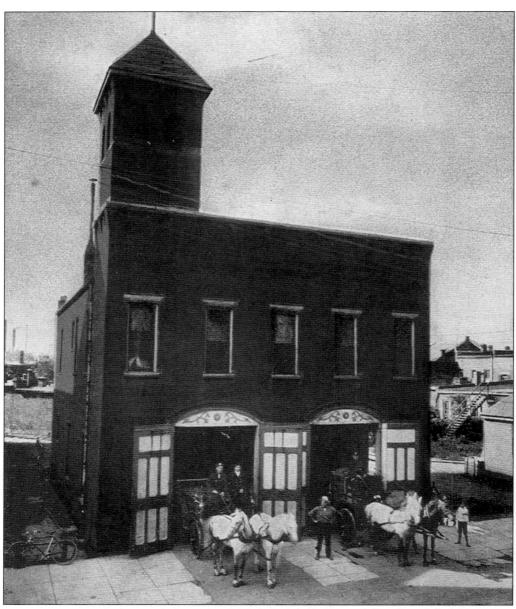

FIRE HOUSE. This brick fire station with large wooden doors was located on the south side of Fifth Street just west of city hall, and was built in 1895. The view shows the horse-drawn fire wagons that were used at the time, along with the tall tower that served two purposes. It allowed easier viewing of smoke and fire in the area and also aided in drying the fire hoses by allowing them to hang high inside the tower. In historical documents, this station is also sometimes called Central Fire Station, Downtown Fire Station, or Old Number One. The building was used well into the 20th century and was later modified to accommodate motorized fire trucks as well. Around 1940, a newer fire station was built downtown—also called Central Fire Station—and the old building was razed. This unsent divided back card is *c.* 1907–1915.

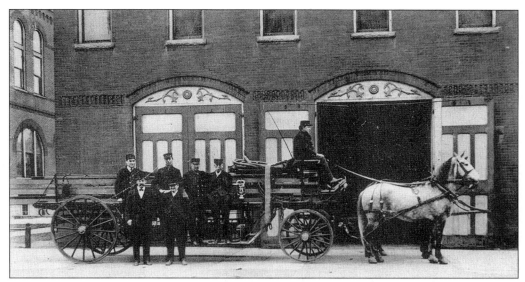

FIRE DEPARTMENT. This view shows the Columbus Fire Department standing in front of the fire station on Fifth Street. A volunteer fire department had existed since 1835, with the volunteers initially supplying their own buckets to fight fires. After the station was built, the fire department consisted of a paid staff of four men, a fire chief, and 29 volunteers. Prior to 1918, the department owned only horse-drawn vehicles. This view appears to show a two-horse ladder wagon *c.* 1910.

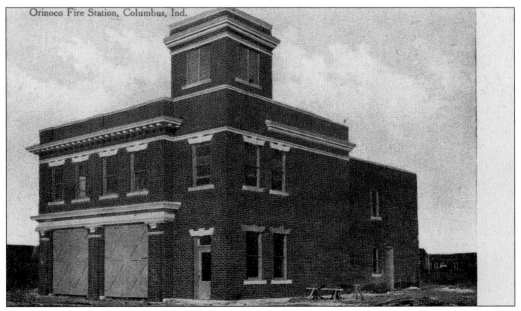

ORINOCO FIRE STATION. This station was also called No. 2 Fire House and was built in 1908 at Thirteenth and Hutchins Avenue, when the growth of Columbus necessitated a fire station northeast of downtown in the Orinoco neighborhood. Three firemen, two horses, and one fire wagon occupied this new building. A motorized fire truck was not added until 1920. This building survives today.

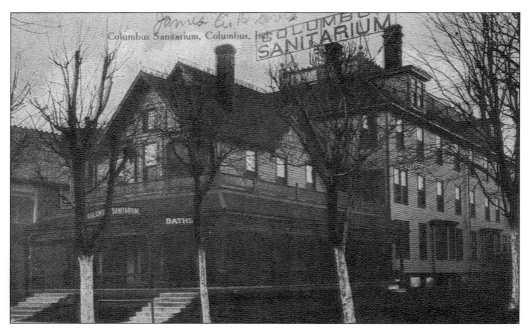

COLUMBUS SANITARIUM, 1909. Located at 722 Fifth Street, this was one of the earliest hospitals in Columbus. It was run by Dr. John Morris, who provided what was thought to be very innovative treatment in the indoor pool in the basement. This card was sent in 1909 within Columbus from James Davis to Peter Davis with the message, "If you are not useing (*sic*) your scythe when you come to town brink (*sic*) it in so I can mow up the potatoes patch."

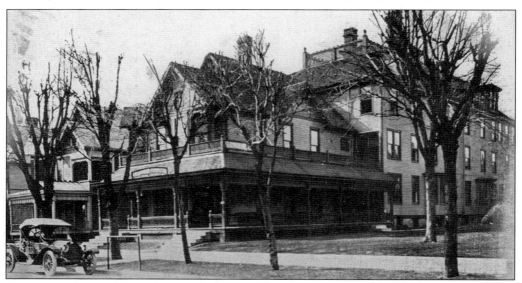

COLUMBUS SANITARIUM, 1912. After Dr. Morris' death in 1912, this building was known as City Hospital, until the Bartholomew County Hospital was built in 1917. The H. C. Whitmer Company then used the building for over 30 years to manufacture various medicinal and household products. It was torn down in 1965 for the construction of Lincoln Elementary School. This card was sent in 1912 from Columbus to Bloomington, Indiana.

ORPHANS HOME, 1908. The Frances Comfort Thomas Home was opened in 1893 in east Columbus on the northeast corner of Illinois and Cherry Streets. It was named for the wife of the man who donated the land for its construction. In November 1908, the card was sent to Minnesota, and the sender writes, "We had a little rain yesterday. The first for many weeks. Our cistern was empty six weeks. You know what that means."

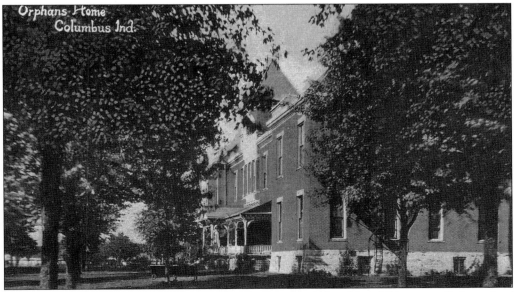

ORPHANS HOME. As many as 74 children lived here, and the older children supplied much of the labor inside the home and on the surrounding 19-acre farm. Much of the food came from the large garden and from the cows and chickens on the property. Gradually maintenance of the antiquated facilities became too expensive, and a newer building was built in the 1960s to replace the older home, which was demolished. This card is unsent and *c.* 1907–1915.

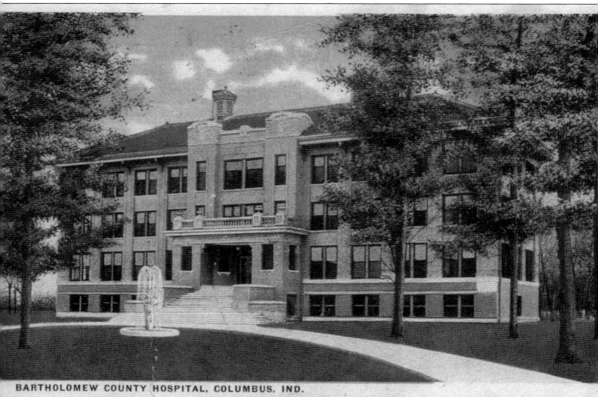

BARTHOLOMEW COUNTY HOSPITAL, COLUMBUS, IND.

BARTHOLOMEW COUNTY HOSPITAL. The county hospital was built on nine acres east of Columbus on Seventeenth Street and opened to the public on February 6, 1917. At the time, this was outside city limits and a considerable distance from much of the town; Seventeenth Street had to be extended and a new bridge built over nearby Haw Creek in order to get to the new hospital. The cost of this original 32-bed facility was $69,442. The birth of Mildred Cummins, daughter of Cummins Engine Company co-founder Clessie Cummins, on July 7, 1917, was the first in the new hospital. Today the hospital still stands in the same location, although after multiple renovations and expansions, it no longer resembles this view. In 1992, the name was changed to Columbus Regional Hospital, and the original building seen here was razed in 1995. This card is unused and *c.* 1917–1930.

Four
BUSINESSES &
ADVERTISEMENTS

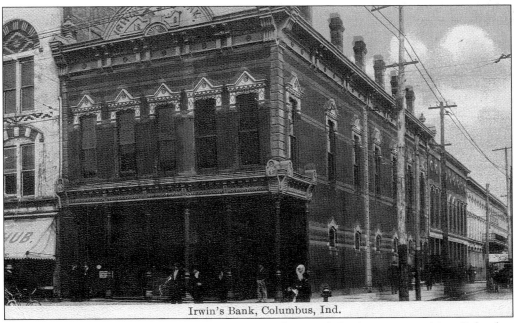

Irwin's Bank, Columbus, Ind.

IRWIN'S BANK. Irwin's bank was founded in 1871 by Joseph Irwin, an enterprising Columbus native. He began his banking business within his dry good store at 327 Washington. He moved to the building pictured here at the corner of Third and Washington in 1882, and the building still stands today. Joseph Irwin died in 1910, and this card was sent in September of that year.

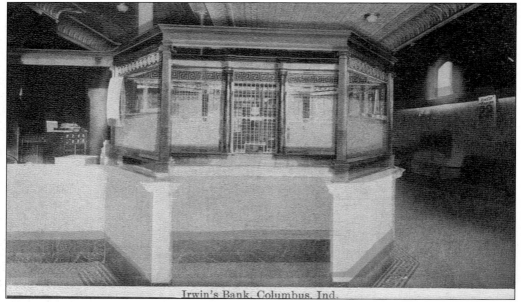

Irwin's Bank, Columbus, Ind.

A "SAFE" PLACE. Prior to opening his bank, Mr. Irwin had the largest safe in town in his dry goods store, and local merchants often asked to leave their money with him, as his safe was felt to be the safest in town. Gradually he realized the potential of a banking business. At the time of these unsent cards (*c.* 1910) the bank had capital of $120,000 with assets over a million dollars.

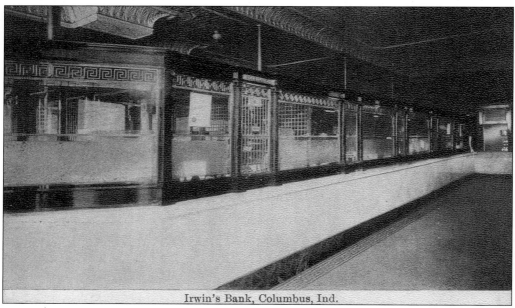

Irwin's Bank, Columbus, Ind.

BANK INTERIOR. Joseph Irwin had business savvy that became apparent at a young age. He was working on his family farm north of Columbus, when he decided to leave at age 22 to make his fortune. His mother gave him 30¢ for train fare, but in the first of many smart business decisions, he decided to keep the money and walk. Within four years, he had saved enough money to open his store. Irwin's Bank is still in operation today as Irwin Union Bank.

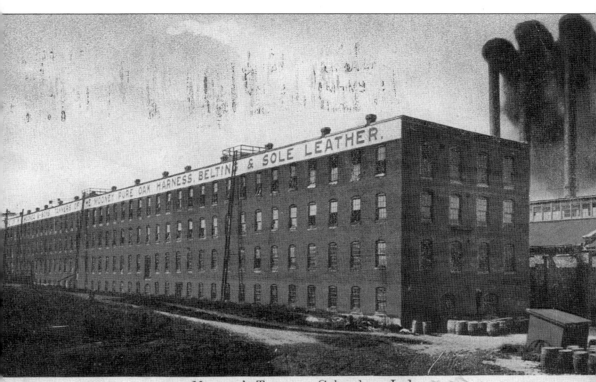

Mooney's Tannery, Columbus, Ind.

MOONEY'S TANNERY. Mooney's was located at the west end of Fifth Street near the train station and at the edge of what would later become Mill Race Park. Edmund Mooney started his business in 1937 in Nineveh Township on a farm in northwestern Bartholomew County and moved it to this location in 1863. The business later became known as Mooney and Sons and was quite successful. Around 1890, Mooney's Tannery was reportedly the largest tannery in the world, employing 75 and producing over a million pounds of leather per year. Products produced here included the Mooney Pure Oak Harness, Flexible Sole, and Belting Leather. Mooney leather was reportedly sold all over the United States and in some foreign countries. Prior to its closing in 1962, Mooney's was considered the oldest industry in Bartholomew County. The building was demolished in 1963. This card was sent from Columbus to Missouri in 1909.

St. Denis Hotel, Columbus, Ind.

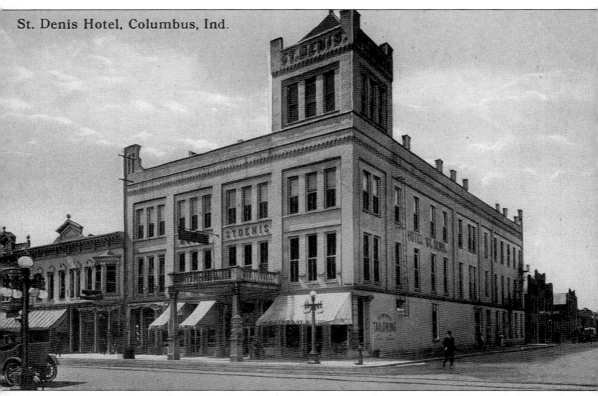

ST. DENIS HOTEL. The St. Denis was built around 1875 at the corner of Fifth and Washington and was one of four hotels in Columbus in the 1880s. The St. Denis was always considered a fancy, first-class establishment. Originally the Palace Theatre was located in the ground floor of the building, but a fire in 1894 destroyed the theater. It was during the rebuilding that occurred after the fire that the tower was added to the top of the building. The St. Denis lobby was one of the central areas in Columbus, and according to a 1956 account, "The St. Denis lobby in those days was a public loafing place where forty or fifty business men and lawyers gathered before church Sundays to settle the national affairs." This card was not postmarked but was dated January 6, 1917, by a traveler attempting to leave town during a period of flooding. The messenger writes, "Marooned on accord of high water in White river bottoms—had to return from within 4 miles of Seymour."

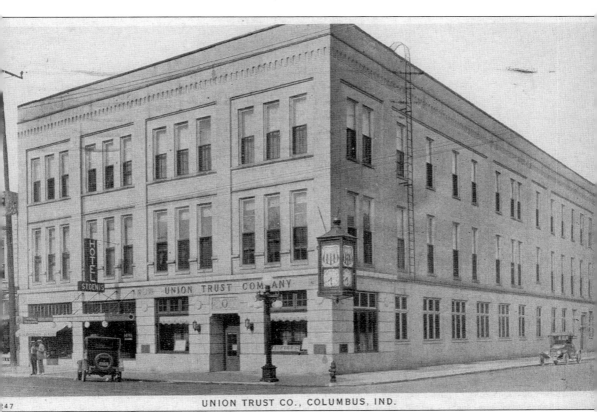

UNION TRUST CO., COLUMBUS, IND.

UNION TRUST. After Union Trust purchased the St. Denis Hotel building in 1928, the building's tower was removed. A smaller sign along Washington Street shows that the St. Denis Hotel still operated in part of the building. That same year, Irwin's Bank and Union Trust merged to form Irwin-Union Trust Company at this location. Run by W. G. Irwin, son of Irwin's Bank founder Joseph Irwin, the bank survived the great stock crash of 1929 because W. G. converted much of the assets to cash after recognizing the signs of impending financial disaster. Several more generations of the Irwin Family have run the bank in the years since, and today Irwin Union Bank is still a large presence in and around Columbus, with the headquarters now located across the street from the building in this view. Over the years, this building has also been home to a telephone company, tailoring businesses, drug stores, and other banks and financial services. The card is postmarked August 9, 1933, from Columbus to Kansas City.

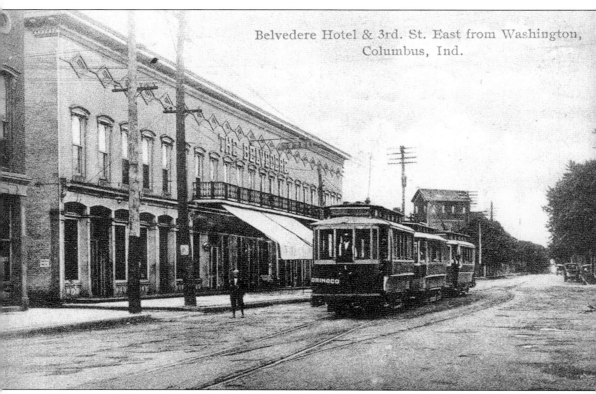

Belvedere Hotel & 3rd. St. East from Washington, Columbus, Ind.

BELVEDERE HOTEL. The Belvedere Hotel was located in a quarter block building at Third and Franklin Streets. Originally the building housed the Bissell Hotel, which was described as "moth-eaten" by an early Columbus citizen. Prominent businessman John Crump, who also founded the Crump Theater across the street, remodeled and renamed the establishment in the 1890s. Visible also in the view is the electric streetcar system established by Crump to travel within Columbus. His first streetcar line was opened in 1890 and was pulled by mules; the electric line was opened in 1893. This particular car traveled to the Orinoco neighborhood east and north from downtown. This building burned in 1967 and was rebuilt as the Surrey Inn. Later it was sold to the county, and currently it holds county offices. The card was sent on October 29, 1914, from Columbus to Raub, Indiana, and the sender admits to staying elsewhere: "Here we are. We are tonight St. Denis Hotel. Drove about 178 miles today expect get to Grandma White tomorrow evening."

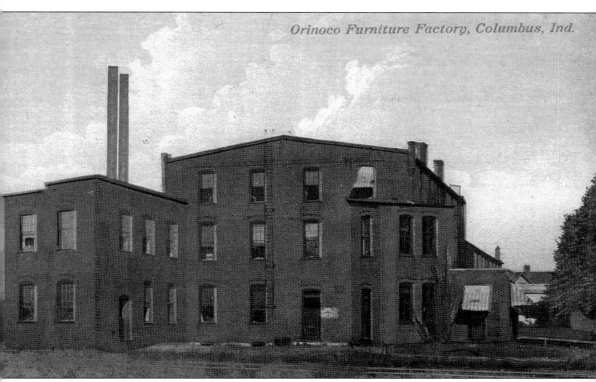

Orinoco Furniture Factory, Columbus, Ind.

ORINOCO FURNITURE FACTORY. This card was postmarked within Columbus in 1911. The Orinoco Furniture Company was founded in 1890 in Hartsville, Indiana, and sold to W. H. Lincoln and George H. Lucas, who built this factory in the Orinoco district of Columbus. By the early 1900s, it was one of the largest employers in town, employing nearly 600 people. The factory was located at Seventeenth and Orinoco Avenue. The company specialized in elegant bedroom and dining room furniture and developed a reputation for producing top-of-the-line products with very fine craftsmanship, which were sold all over the United States. The Lincoln Chair Company was a spin-off of the Orinoco business in 1913 and made pieces to accompany Orinoco sets. Eventually the two companies merged into the Lincoln–Orinoco Company. The Great Depression was very hard on the business, and by 1940, the company was closed. Part of this building survives today.

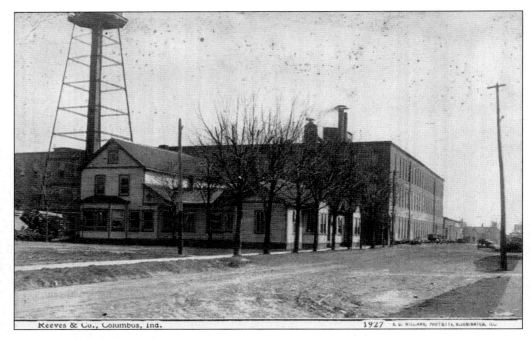

Reeves & Co., Columbus, Ind. 1927 E. D. WILLIAMS, PHOTO, BLOOMINGTON, ILL.

REEVES & CO. The Reeves family came to Columbus in 1875 and started what would become one of Columbus' largest manufacturing businesses. They founded the Columbus Wheel Company and later changed the name to Reeves & Co. The company manufactured agricultural implements, including threshing machinery and sawmills, and was located at Fifth and Wilson Streets. This card was sent in 1914 from Columbus to Sheldon, Illinois.

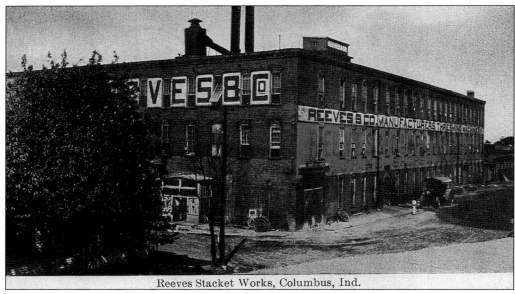

Reeves Stacket Works, Columbus, Ind.

REEVES STACKET WORKS. This card carries a misprint, as Reeves held a patent on a device called a "stacker" that was used in harvesting and stacking straw. The building pictured is the same as that seen in the previous view. This card was sent in 1909.

58

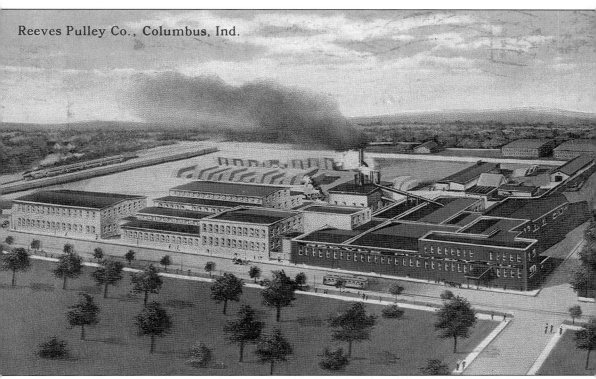

Reeves Pulley Co., Columbus, Ind.

REEVES PULLEY CO. The pulley company began in 1888 with the manufacturing of pulleys within a small section of the Reeves & Co. plant. The Reeves split wood pulleys were used to power factory machines prior to the age of the electric motor, and until electric motors became commonplace, the Reeves pulleys were shipped all over the world. Unlike the stackers or threshing machinery of Reeves & Co., pulleys were not seasonal equipment, so the factory ran year-round. The first section of this building was built in 1890, and the plant eventually grew to occupy more than 300,000 square feet. The company continued to invest in what was then new technology and went on to produce a clutch and a variable speed transmission for use in automobiles and large machinery. The Reeves Pulley Company was located at 1225 Seventh Street at the corner of Seventh and Wilson. The card was sent from Vincennes, Indiana, to Bicknell, Indiana, in 1917.

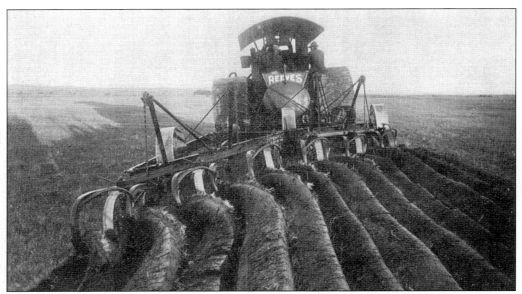

REEVES PLOW. This was an advertising card printed to market one of the large agricultural machines produced by Reeves & Co. The card is stamped on the back "Reeves & Co., Denver, Colorado" and shows the widespread popularity of the Reeves equipment. It has not been postmarked and is *c.* 1907–1915.

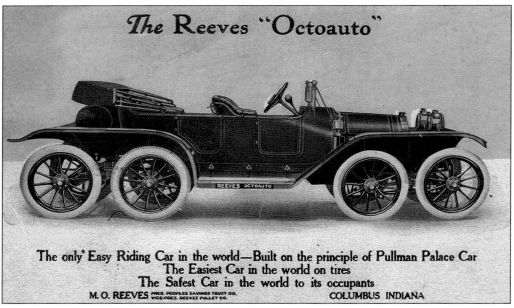

REEVES OCTOAUTO. This advertising card showcased an unusual motorized car with eight wheels. It was designed by M. O. Reeves, a prolific inventor and vice-president of the Reeves Pulley Company. Designed around 1910, the car featured eight wheels, which were supposed to make a smoother ride. Although this car did not achieve widespread popularity, M. O. Reeves also designed more traditional cars and motors for cars produced by other companies.

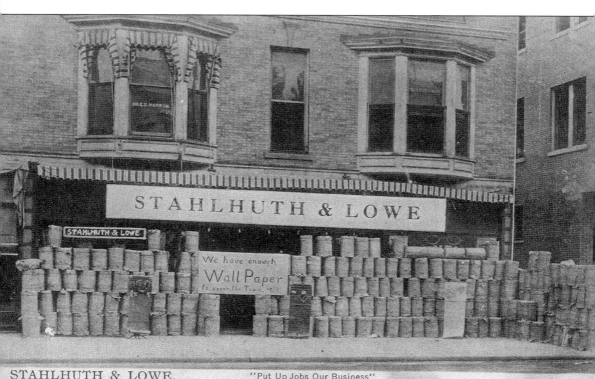

STAHLHUTH & LOWE,
Drugs, Paints, Wall Paper,
423 Washington St., Columbus, Ind.

"Put Up Jobs Our Business"
"Wall Paper In Car Loads Or Material"
"Efficient and Prompt Service with Unbeatable Prices Should Secure your Order"
"Come at once for Choice Designs."

STAHLHUTH & LOWE. This business was located at 423 Washington Street in the early 20th century. The card was mailed on March 6, 1914, with the typed message on the back to a customer in nearby Hartsville, Indiana, reading, "We beg to announce a few sample books which will contain some of the most attractive wall papers in our line. We presume that you will want to decorate one or more rooms this year. Whether you do or not we would be pleased to have you call for this book as we have one reserved for you. We can offer you the best of service as we have ten decorators employed." According to city directories of the period, the business was also a drugstore that sold books, stationery, cameras, photographic supplies, and school supplies as well. This building survives today in the heart of downtown Columbus.

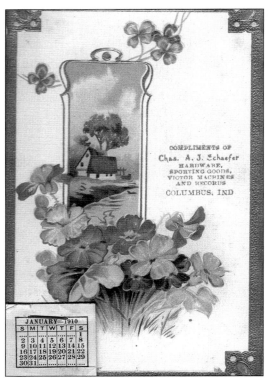

CHARLES SCHAEFER HARDWARE. This unused card from 1910 advertised for Charles A. J. Schaefer and his downtown business, which was located at 1024 East Third Street. The Columbus city directory at the time shows the business was also called Columbus Hardware. Visible on the card is a calendar for January 1910, but this mini-calendar contains small sheets for each month of the year stapled together.

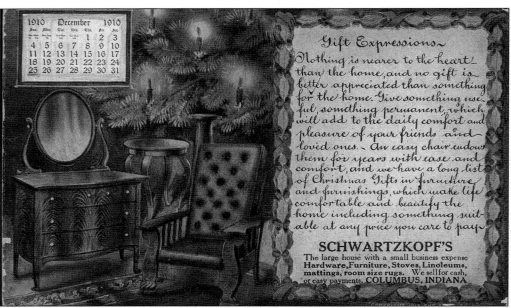

SCHWARTZKOPF'S. This early unsent card advertises another downtown establishment with a colorful holiday scene, complete with candles on a lighted Christmas tree. Schwartzkopf and Sons Hardware was another business that sold a very wide variety of products, as promoted on the card. The company was located at the corner of Third and Washington Streets.

FEHRING CARRIAGE CO., 1908. The Fehring Carriage Company was located at 601 Third Street. In this 1908 advertisement, the company markets its buggies and harnesses, reflecting the fact that horse-drawn vehicles were still much more common than automobiles at the time. This card is addressed and stamped, but is not postmarked.

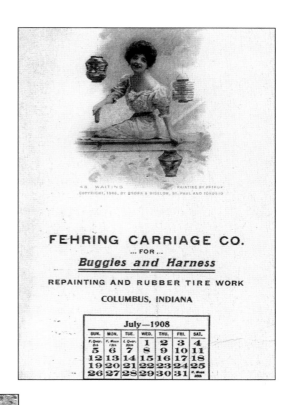

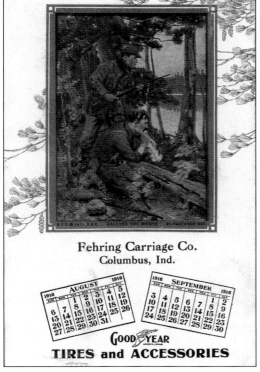

FEHRING CARRIAGE CO., 1916. By the time of this 1916 card, the company has moved forward to advertise parts for automobiles as well, including Goodyear tires. The emotions evoked by this card that depicts two hunters in the woods are much different than the previous card. The building in which Fehring was located no longer stands today.

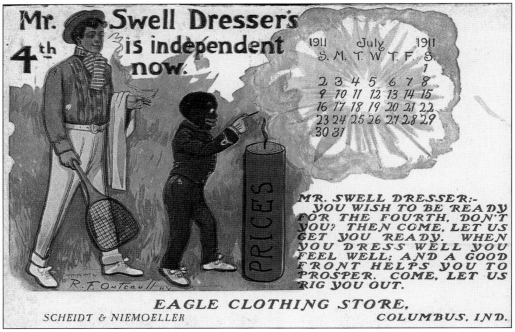

EAGLE CLOTHING STORE. Also known as Scheidt & Niemoeller, this business was located at 328 Washington Street in the block now occupied by the Commons Centre Mall.

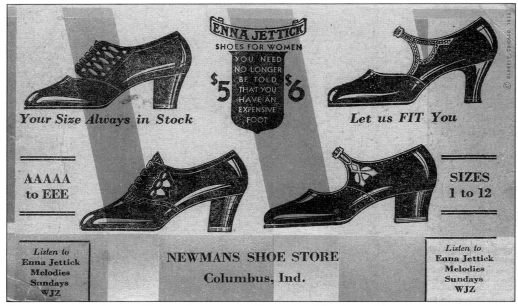

NEWMANS SHOE STORE. This card was sent in November 1931 from Columbus to East Columbus City. East Columbus was once its own town but is today part of Columbus. At the time of this card, the shoe store was run by Mr. Nathan Newman and was located at 413 Washington.

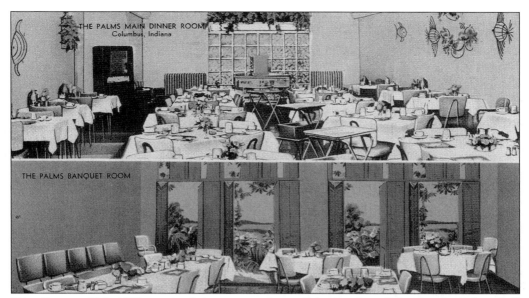

THE PALMS MAIN DINNER ROOM
Columbus, Indiana

THE PALMS BANQUET ROOM

THE PALMS. This 1950s–era card shows two views of the interior of the popular Palms Café located on Fourth Street. In the 1960s, the Palms became the Hollywood Café, and today the building houses Fourth Street Bar and Grill. The back of this unsent card reads, "Southern Indiana's newest and finest Food and Cocktail Lounge where fine foods are at their best and cocktails are superb. At The Palms you will enjoy the friendly and relaxing atmosph ere created by the latest in architecture. . . ."

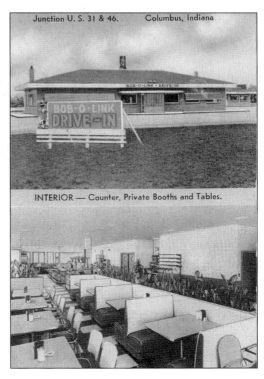

Junction U. S. 31 & 46. Columbus, Indiana

INTERIOR — Counter, Private Booths and Tables.

BOB-O-LINK DRIVE-IN. Another 1950s-era card showcases the Bob-O-Link, where diners could drive-in or eat inside. The business was located near the intersection of U.S. 31 and S.R. 46 (today National Road and Twenty-fifth Street) and was long ago demolished. The card is unsent but a handwritten note on the back explains, "On Sundays there were 86 waitresses who served around 3000 people. Really good food."

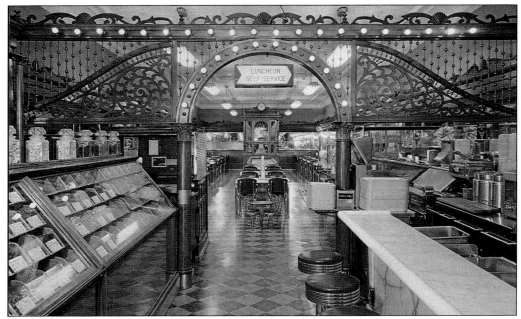

ZAHARAKO'S INTERIOR. Located at 329 Washington Street, Zaharako's soda shop and confectionary has been run by the Zaharako family since 1900 and is known to locals as "The Greek's." Standing proudly at the back of the store is a full concert German pipe organ, imported in 1908. The magnificent machine plays songs of a century ago with the sounds of trumpets, clarinets, snare and bass drums, cymbals, flutes, and more.

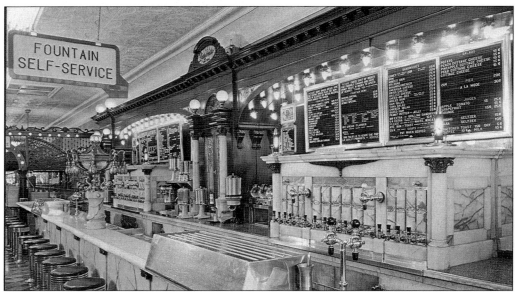

ZAHARAKO'S SODA FOUNTAIN. Looking today just as it has for the last century, Zaharako's includes antique Mexican onyx soda fountains purchased in 1905 at the St. Louis Exposition and World's Fair. The solid mahogany back bar and Italian marble and Mexican onyx counters were installed in 1911. Today hungry customers can still buy sandwiches, drinks, and ice cream treats.

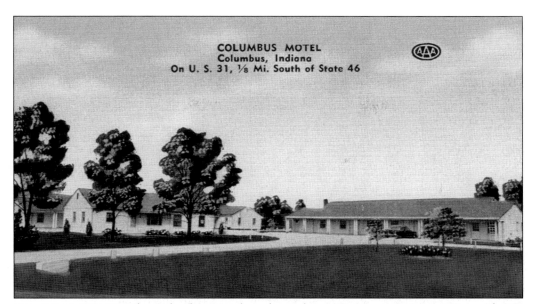

COLUMBUS MOTEL
Columbus, Indiana
On U. S. 31, ⅛ Mi. South of State 46

COLUMBUS MOTEL. The Columbus Motel was located on U.S. 31 near its intersection with S.R. 46. This was very close to the Bob-O-Link drive-in. The card is unsent, and information on the back includes the following: "22 Modern Units—Air Cooled—Central Heat—Private Tile Baths—A Good Restaurant Adjacent—Some Rooms with PREVIEW TV." The motel was torn down in the early 1990s.

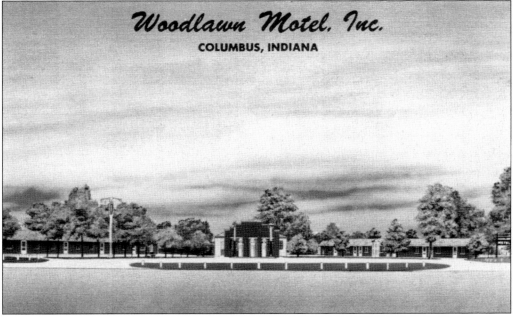

Woodlawn Motel, Inc.
COLUMBUS, INDIANA

WOODLAWN MOTEL. The 1950 Columbus City Directory shows the Woodlawn Motel was located on Louisville Road. It the 1970s, the motel's address was listed as 365 South National Road. Presumably the motel was closed in 1975, because after this it cannot be found in a city directory or city phone book. The card is unsent.

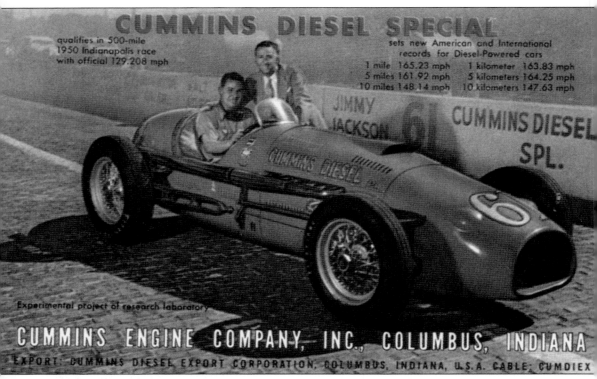

CUMMINS DIESEL SPECIAL

qualifies in 500-mile
1950 Indianapolis race
with official 129.208 mph

sets new American and International
records for Diesel-Powered cars

1 mile 165.23 mph 1 kilometer 163.83 mph
5 miles 161.92 mph 5 kilometers 164.25 mph
10 miles 148.14 mph 10 kilometers 147.63 mph

Experimental project of research laboratory

CUMMINS ENGINE COMPANY, INC., COLUMBUS, INDIANA
EXPORT: CUMMINS DIESEL EXPORT CORPORATION, COLUMBUS, INDIANA, U.S.A. CABLE: CUMDIEX

CUMMINS ENGINE COMPANY. Since its founding in 1919 by Clessie Cummins and W. G. Irwin, Cummins has been one of the most important driving forces in the development and improvement of Columbus. Clessie Cummins was a mechanic and inventor who originally worked as a chauffeur for the Irwin family and who felt that diesel technology would prove to be durable and economic for engine design. The company initially created mostly agricultural and marine motors but quickly realized the market for automotive engines. In 1940, Cummins offered the first 100,000-mile warranty on its engines, and impressive performances in the Indy 500 served to spread the word about Cummins in the early years. As seen in this card, a Cummins engine powered Jimmy Jackson in the Indianapolis 500 in 1950. He finished 29th out of 33 cars with an average speed of 129.2 miles per hour and won $1,939. The back of the card includes a list of the uses for Cummins Lightweight High-speed Diesel Engines, including trucks, buses, tractors, earth-movers, industrial locomotives, drilling rigs, and various boats.

Five

CHURCHES

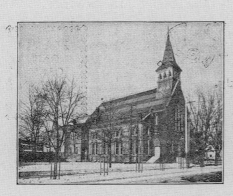

You are cordially invited
to be present at a banquet
given at the Church by the
pastor, William Henry
Book and wife, to the Eld=
ers and Deacons of the
Church, Tuesday, October
1st, nineteen hundred seven,
from 7:30 to 10:00 o'clock
P. M.

TABERNACLE CHRISTAIN CHURCH,
Columbus, Indiana.

TABERNACLE CHRISTIAN CHURCH, 1907. This unused card dates from 1907. At that time, mail was an important method of communicating news—including church news—and this card was sent to elders and deacons in the church, inviting them to a church banquet. The Tabernacle Christian Church (note the misspelling on the card) stood along Mechanic Street (now Lafayette) between Fifth and Sixth Streets.

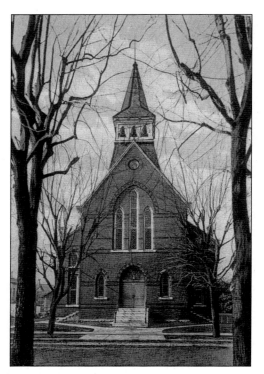

TABERNACLE CHRISTIAN CHURCH. Built in 1878, the church was designed by the same architect who designed the Joseph Irwin home, which was right across the street. Reportedly, when the previous church building at Fifth and Jackson became too small for its membership in 1877, the Reverend Zachary Sweeney gave an impassioned sermon one Sunday and announced that the doors of the church would remain closed until $10,000 was raised to build a new church. The money was quickly pledged. Today the street where this view was made no longer exists, as the stretch of Mechanic (now Lafayette) was closed off between Fifth and Sixth to enlarge the library after the Tabernacle had moved in the early 1940s.

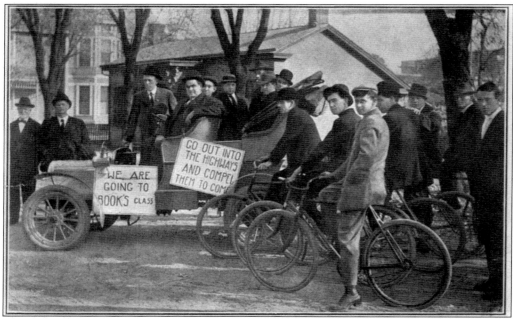

TABERNACLE ADVERTISEMENT. On the back of this unsent card *c.* 1910 is the typed message, "Tabernacle Church, Columbus Indiana. Dear Friend: Will you not join us? We shall look for you Sunday. Truly, Committee."

TABERNACLE CHURCH OF CHRIST. This card shows the first significant contemporary architectural building in Columbus. The Tabernacle (later First Christian Church) was designed by Eliel Saarinen and built on the site of the former Railroad Square. It was completed in 1942 and designed to convey the parishioners' belief in the simplicity of the ideals of the New Testament.

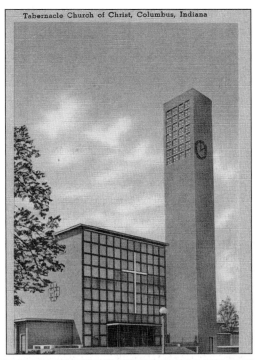

Tabernacle Church of Christ, Columbus, Indiana

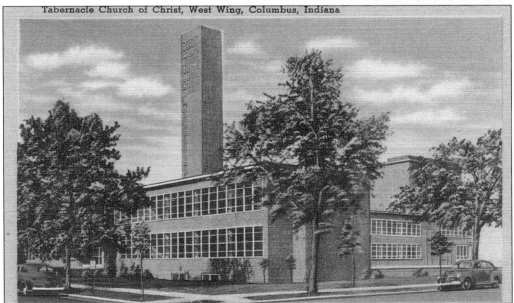

Tabernacle Church of Christ, West Wing, Columbus, Indiana

TABERNACLE CHURCH OF CHRIST, WEST WING. The idea of experimenting with non-traditional architecture for the church's design originated with J. Irwin Miller, the head of Cummins Engine Company and grandson of the Reverend Sweeney (pastor of the previous Tabernacle built in 1878). People in Columbus were fascinated with the unique design of this church as it was constructed, and today visitors still come from far away to appreciate a remarkable example of modern architecture.

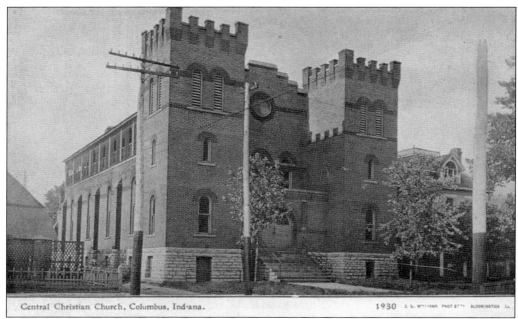

Central Christian Church, Columbus, Ind·ana. 1930 C. L. WILLIAMS PHOTO STUDIO BLOOMINGTON ILL

CENTRAL CHRISTIAN CHURCH, 1930. Completed in 1886 and designed by Charles Sparrell, who also designed city hall, this building was reportedly built by a disgruntled pastor of the Tabernacle who was unhappy with his low wages. The building carried a garden on the roof and only served as a church for a few years, after which it was sold. This card is unused.

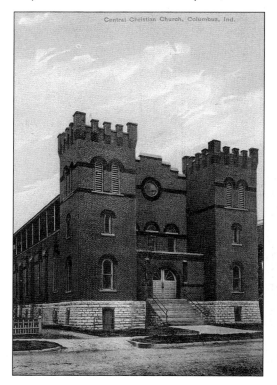

Central Christian Church, Columbus, Ind.

CENTRAL CHRISTIAN CHURCH. This card shows another view of the church. While the card is *c.* 1907–1915, the Columbus City Directory from 1915 states Central Christian Church had "no regular pastor or services." The building survives today on Seventh Street between Lafayette and Pearl and has been converted into apartments.

M. E. Church, 1910. The Methodist Episcopal Church was also designed by local architect Charles Sparrell. The building was dedicated in 1887 at the corner of Eighth and Lafayette. The cost of construction was $25,000. This real photo card is *c.* 1910, and a vintage carriage is visible in the lower right corner of the view.

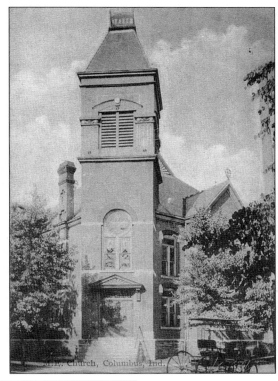

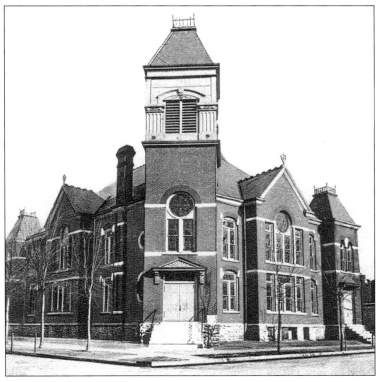

M. E. Church, 1907. This card shows a somewhat earlier view of the church dated September 1907, but not postmarked. Remodeled several times and now carrying a taller and narrower steeple, the church is still in use as First Methodist Church in Columbus. Handwritten on the card is information about church conference that year. Also on the back is the message, "Ben and I stopped at Belvedere. Took dinner with Mrs. Coats."

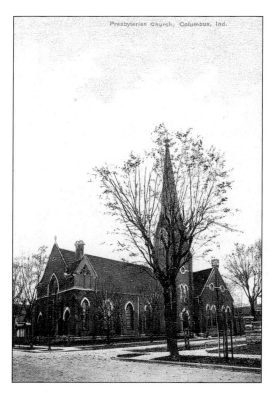

PRESBYTERIAN CHURCH. This card was sent from Columbus to Gillmore, Ohio, in 1910. The First Presbyterian Church was organized in 1824, and the first building constructed by the church was located on Third Street in the 1840s. This building was started in 1871 and first used by the church in 1875, although the sanctuary was not finished until much later in 1885. This structure remains in use today.

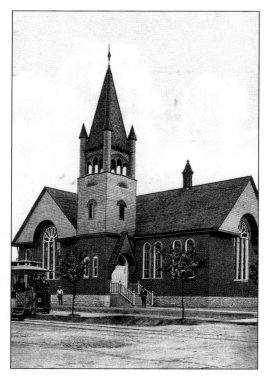

ENGLISH LUTHERAN CHURCH. This card was sent in July 1909, to Flat Rock, Indiana, but the picture is much older and can be found in an 1898 book about Columbus. The church was dedicated in 1894. As seen in the picture, the streetcar ran right by the church. Today the building can still be found on Chestnut Street at Eleventh Street, as the home of Calvary Community Church.

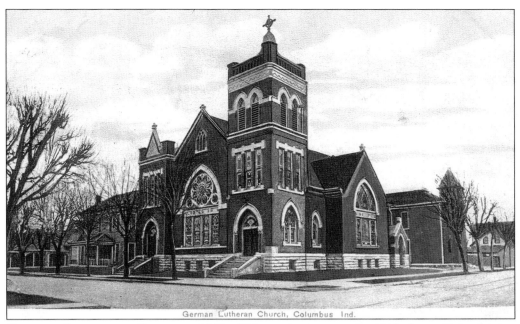

German Lutheran Church, Columbus Ind.

GERMAN LUTHERAN CHURCH, 1910. This card was sent in 1910 from Columbus to Indianapolis with the message written in German. In the late 1800s, five different German Lutheran congregations existed in Bartholomew County. This view of the Columbus congregation shows the large brick church that was built in 1870 at the corner of Fifth and Sycamore at a cost of $9,000. The two-story brick school near the church was built in 1887.

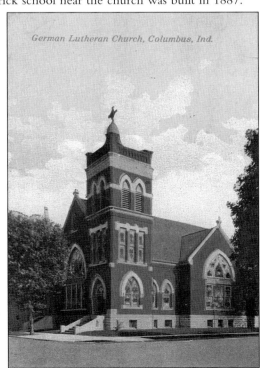

German Lutheran Church, Columbus, Ind.

GERMAN LUTHERAN CHURCH, 1911. This card shows another view of the church and was sent to New Albany, Indiana, from Columbus in 1911. This original church building still stands among a large cluster of buildings that today make up St. Peter's Lutheran Church and School.

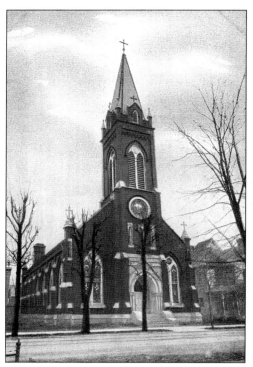

ST. BARTHOLOMEW, 1907. This card is postmarked 1907 from Columbus to Colorado Springs and shows St. Bartholomew Catholic Church, which was built around 1890 at Eighth and Sycamore. Prior to this, there was another Catholic church in Columbus that had been located on Washington Street at the corner of Sixth Street.

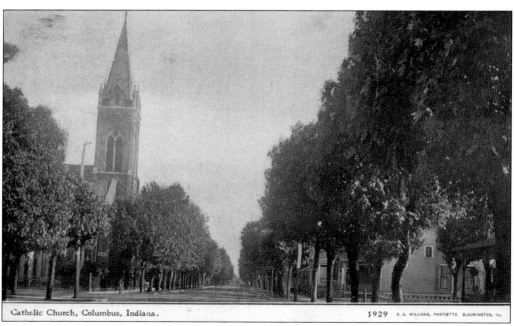

Catholic Church, Columbus, Indiana.

1929 C. U. WILLIAMS, PHOTOETTE, BLOOMINGTON, ILL.

ST. BARTHOLOMEW, 1920S. This 1920s-era real photo card was sent from Columbus to St. Louis, Missouri, but the postmark in no longer legible. The 1929 in the corner of the card refers to the card series and not the year of printing. Shown is a quiet and shaded Sycamore Street where St. Bartholomew was located.

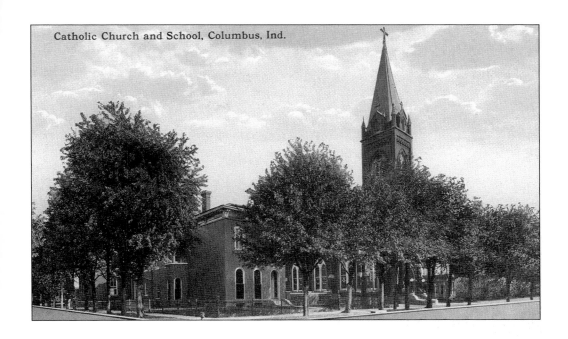

Catholic Church and School, Columbus, Ind.

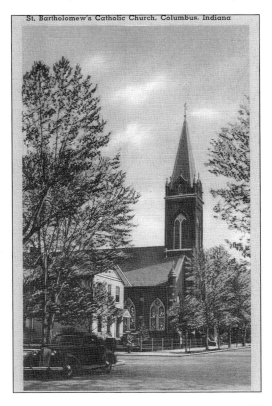

St. Bartholomew's Catholic Church, Columbus, Indiana

CATHOLIC CHURCH AND SCHOOL. Seen here are two more views of St. Bartholomew church and Catholic school. The top card is *c.* 1920s but carries an illegible postmark. The bottom card is unused. In the 1960s, a newer Catholic church, known as St. Columba, was built on the north side of town, and the Catholic school was moved to that location. This building continued to hold services until near the end of the 20th century, when the two congregations were combined, and the united congregation at the newer location became known as St. Bartholomew. While this building is currently vacant, it still stands in downtown Columbus. The newer sanctuary from the 1960s church, however, was demolished in the early 21st century and replaced with a larger and more architecturally interesting building also called St. Bartholomew Catholic Church.

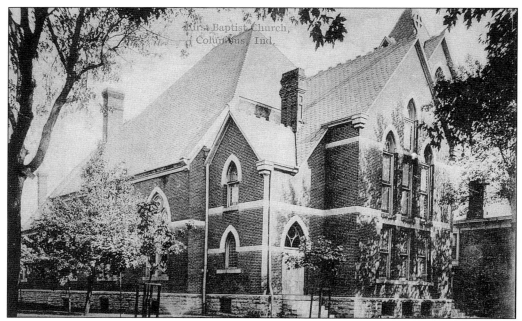

BAPTIST CHURCH. First Baptist Church was built in 1855 on Franklin Street between Sixth and Seventh Streets for a cost of $3,000. A new front was added onto the building in 1886. This real photo card was shows the side of the church. The card is unused and *c.* 1910.

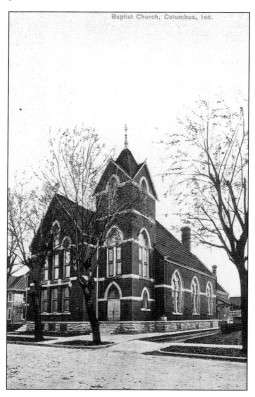

BAPTIST CHURCH AND SPIRE. This *c.* 1910 unused card shows another view of First Baptist. A new, larger Baptist church was built in 1965 on the northeast side of Columbus, and this building was abandoned. It was later torn down to make space for a larger parking lot for the new library.

Six
HOMES & RESIDENTIAL VIEWS

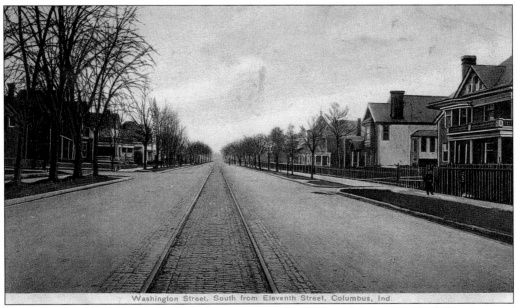

Washington Street, South from Eleventh Street, Columbus, Ind.

WASHINGTON SOUTH FROM ELEVENTH. This card appears to have a misprint. The view was more likely made looking *north* from Eleventh. Looking south, the courthouse and other downtown buildings should have been visible in the distance. In addition, a variety of larger and more stately homes stood in the block between Tenth and Eleventh and are not seen here. This card was sent on January 1, 1908, to Louisville, Kentucky. The sender writes, "Am taking in the town."

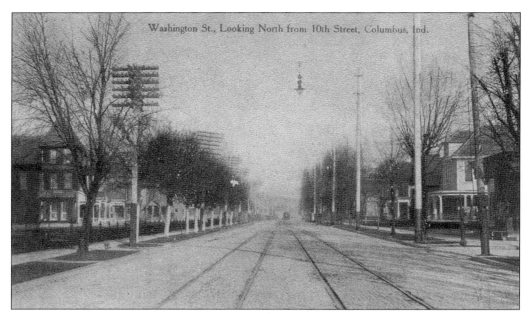

Washington St., Looking North from 10th Street, Columbus, Ind.

WASHINGTON NORTH FROM TENTH. Once five homes owned by the Crump family stood between Ninth and Eleventh on the west side of Washington. Today only two old homes remain standing. On the east side of Washington (right side of card), all the homes have been replaced by retail establishments. Note the two sets of streetcar tracks running down the street, something not seen on many cards. This card was sent to Indianapolis in November 1909.

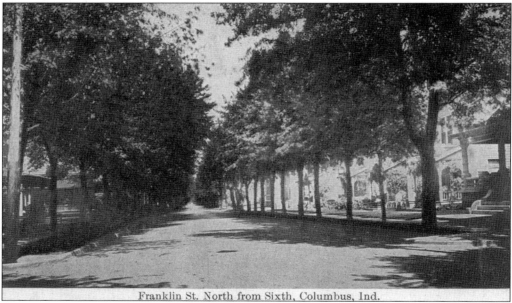

Franklin St. North from Sixth, Columbus, Ind.

FRANKLIN NORTH FROM SIXTH. None of the homes in this view remain today, as the block on the right was cleared for the parking lot for the new library in Columbus. The Baptist Church was also located in this block. This card was postmarked and sent to Forest, Indiana, but the year is illegible.

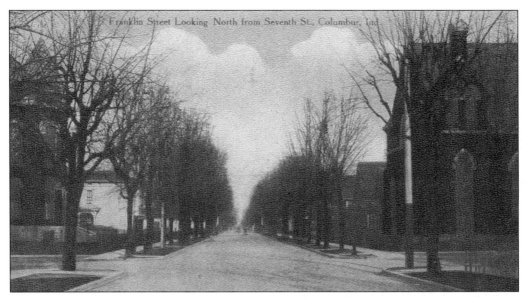

Franklin Street Looking North from Seventh St., Columbus, Ind.

FRANKLIN NORTH FROM SEVENTH. On the corner of Seventh at the right is First Presbyterian Church. The tall home visible with the turret at the left was known as the Beatty-Donner home. This home was built in 1877 and described in 1895 as the "largest, most substantial and most expensive home in Columbus." The home was sold in 1935 to the church and eventually torn down to make room for a telephone company building.

Franklin St., Looking North from Seventh, Columbus, Ind. Pub. by Curry Book Store, Columbus, Ind

FRANKLIN NORTH FROM SEVENTH, 1909. This card shows a view of the houses that were located just past the Presbyterian Church on Franklin Street. None of these old homes survives today, as this is the site of the church parking lot. The card was postmarked in 1909 and sent to Madison, Indiana.

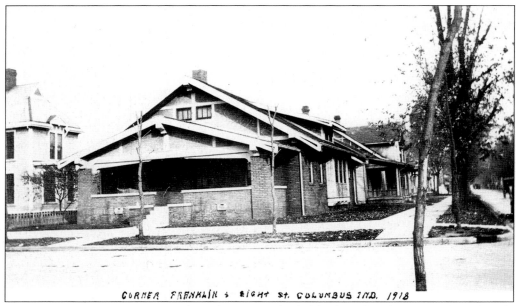

CORNER FRANKLIN & EIGHT St. COLUMBUS IND. 1918

FRANKLIN AND EIGHTH. Pictured on this unsent divided back card is this Arts and Crafts-style home. Written on the back is "Dr. Havens," although in 1918 no Dr. Havens was listed in the city directory. Later in the 1920s and 1930s, a dentist named Dr. Havens can be found with a different address. The home still stands today at the southeast corner of Franklin and Eighth Streets.

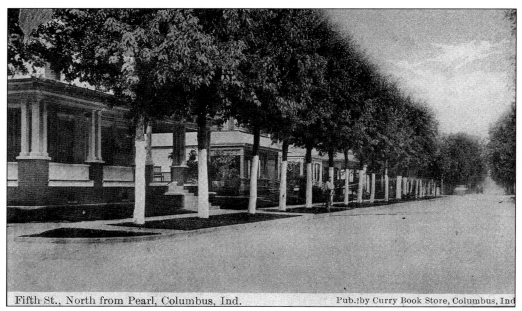

Fifth St., North from Pearl, Columbus, Ind. Pub. by Curry Book Store, Columbus, Ind

FIFTH FROM PEARL. Although the card suggests the view is looking north, Fifth Street actually runs east and west. The view may have been made on Pearl Street looking north from Fifth, as Pearl runs north and south. Today there is no way to know, as Lincoln Elementary School sits at this intersection today, and all the houses that were located on both Fifth Street and Pearl Street at this location are gone.

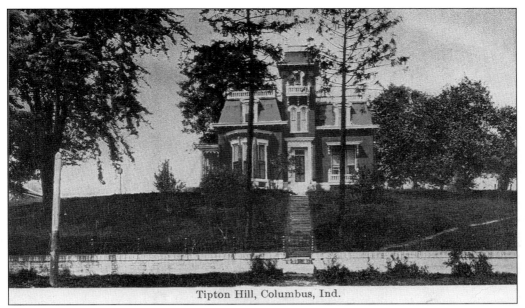

Tipton Hill, Columbus, Ind.

TIPTON HILL. This was once the city's highest point and stood at the end of Third Street next to the White River. General John Tipton, one of the town's founders, built his cabin on the site. It was rumored to have been an Indian mound, but no artifacts or remains were found when the hill was leveled in 1950 for the construction of the new Third Street Bridge. Originally known as the Schwartzkopf home, this building was also used as the VFW headquarters before it was demolished. The card was postmarked September 1910.

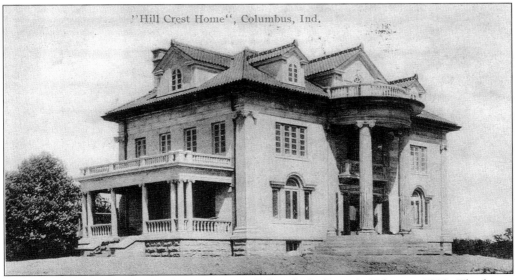

"Hill Crest Home", Columbus, Ind.

HILL CREST HOME. This card was sent to Edinburgh, Indiana, in February 1913. The home was built around 1910–1914. It was sold in 1928 to Fred Whitehouse, president of the H. C. Whitmer Company, which was based in Columbus and which produced medicines, spices, and cosmetics. One of the co-founders of Arvin Industries, Q. G. Noblitt, purchased the home in 1942. It still stands at 1910 Washington.

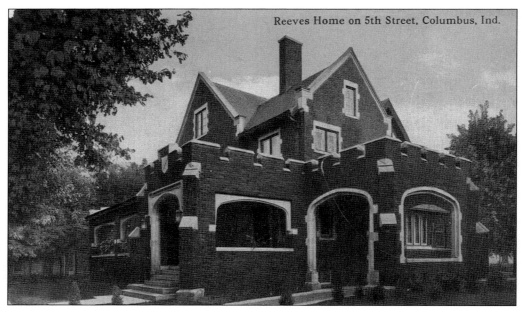

Reeves Home on 5th Street, Columbus, Ind.

REEVES HOME. At one time, five homes on Fifth Street were owned by the Reeves family. This house was home to G. L. Reeves and stood at the southwest corner of Fifth and California. Mr. Reeves and his wife enlarged the home into a spacious mansion with six bedrooms and four baths, and the Orinoco Furniture Company of Columbus installed the moldings and cabinets. The home was demolished in the early 1970s. The card was sent in 1914.

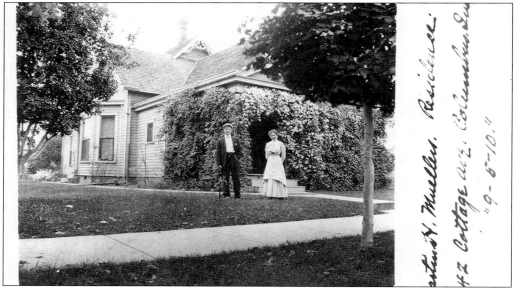

MUELLER RESIDENCE. This card is hand-labeled with the address and names of the owner of this home, Mr. Martin H. Mueller. According to the city directory, Mr. Mueller worked for Rost Jewelers and was married to Fanny E. Mueller. Presumably Mr. and Mrs. Mueller are pictured here in front of their home. This house no longer exists, and the land is located within the grounds of the former Golden Casting Corporation.

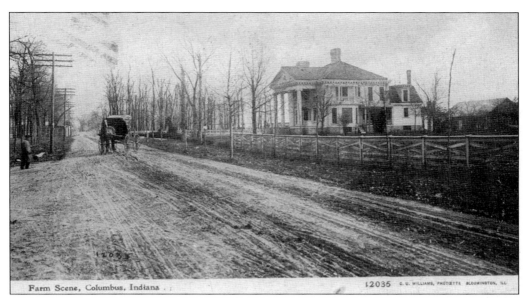

Farm Scene, Columbus, Indiana . ;

12035 C. U. WILLIAMS, PHOTOETTE BLOOMINGTON, ILL

FARM SCENE. This card was sent to Green, Ohio, in March 1911, and shows the Caldwell home, which at the time was located far from the rest of Columbus. The unpaved road would later become Twenty-fifth Street, and the home stood at Twenty-fifth and Caldwell until it was torn down around 1960. Today a bank stands where this home once stood, and this area is the in the heart of Columbus' retail district.

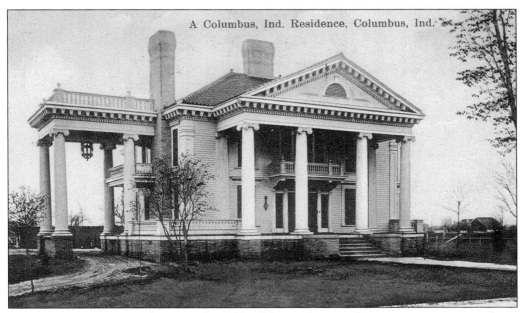

A Columbus, Ind. Residence, Columbus, Ind.

CALDWELL HOME. Over the years, the Caldwell house also served as a tearoom, a teenage dance hall, a guesthouse, and later an early meeting site of the North Christian Church until its new building was completed. George Caldwell was mayor of Columbus around the turn of the century and co-owner of a construction company, which built this home and many others around Columbus and elsewhere.

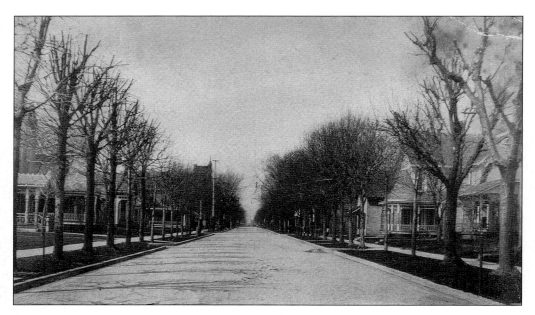

FIFTH STREET WEST. This real photo view shows Fifth Street looking west or towards city hall, which can be seen on the left in the distance. It was taken from at least one block east of the library and Irwin home. The card is *c.* 1910 and unused.

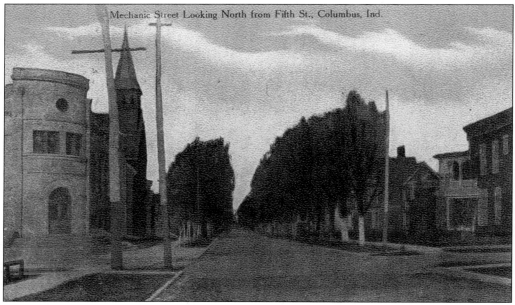

Mechanic Street Looking North from Fifth St., Columbus, Ind.

MECHANIC STREET NORTH. This view shows the relation of the library—which is pictured on the left at the corner of Fifth and Mechanic—with the Tabernacle Church, located just beyond. The home directly across the street, which is partially pictured, is the Irwin home. The card is postmarked 1910.

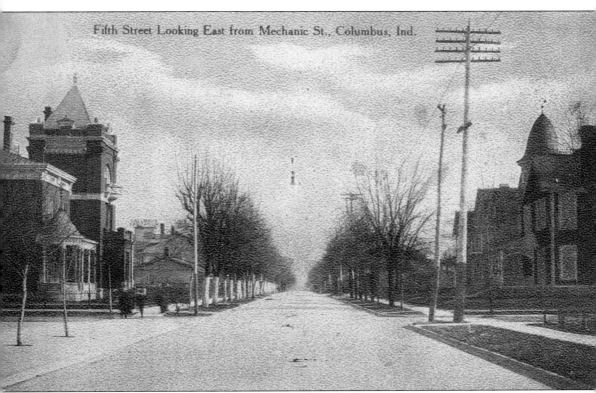

Fifth Street Looking East from Mechanic St., Columbus, Ind.

FIFTH STREET EAST. This view was taken from the corner of Fifth and Mechanic (now Lafayette) Streets looking east on Fifth Street. The stately Irwin home is pictured on the left before a major renovation altered the roofline and other elements. The Irwin home still stands today in this location. Across the street two other Victorian homes are visible which remain today. In the distance on the left, the roofline and sign of the Columbus Sanitarium are visible, showing its location in relation to Fifth Street (see page 50). The sanitarium was one of the original Reeves homes on Fifth Street before it was converted into a hospital. The other Reeves homes would have been farther down past the block pictured here. Standing where this view was taken would have placed the viewer in front of the original Columbus Library, which was replaced with a new and larger library in the same location. This card is unsent and *c.* 1907–1915.

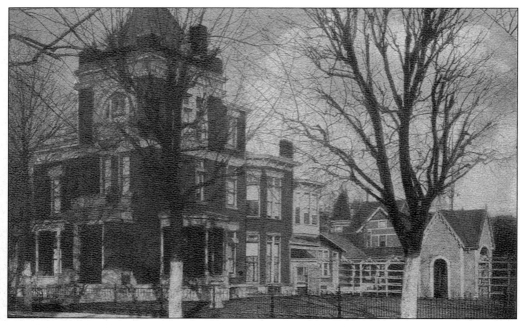

JOSEPH IRWIN'S RESIDENCE. This unsent card *c.* 1907–1910 shows the Irwin home before a large renovation doubled the size of the house and before the sunken gardens were added in the 1910s. The home was designed by Levi Levering, an architect from near Hope, Indiana, and it was built in 1864 by Joseph Irwin.

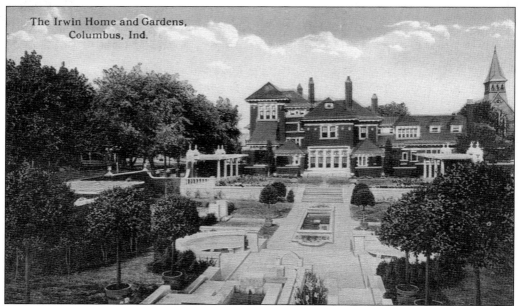

IRWIN HOME AND GARDENS. Visible in this card postmarked August 21, 1919, are both the Irwin home and the sunken gardens. The old Tabernacle Church can be seen in the back right of the card on Mechanic Street The sender writes, "This picture shows a beautiful place on 14 miles from here."

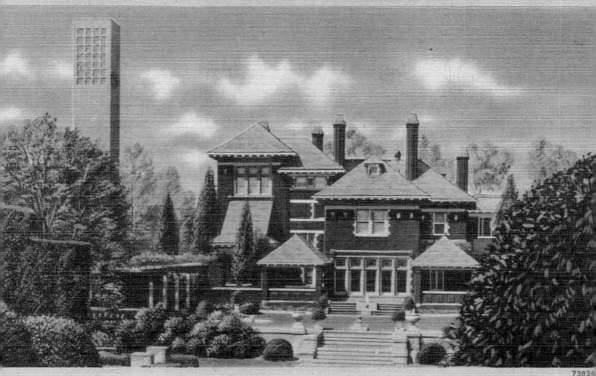

73836

IRWIN HOME AND TABERNACLE. Originally the Irwin home was a two-story brick house, but a renovation in the 1880s added the three-story tower entrance on Fifth Street. The next major expansion and renovation in the 1910s doubled the size of the home and added the gardens. Several generations of the Irwin-Sweeney-Miller family have lived in the home, which remains in their possession. Compared to the previous card, this linen 1940s card shows the view across the gardens a quarter century later, with the tall tower of the modern Tabernacle in its new location on the other side of Fifth Street. The juxtaposition of the Irwin home with both the old and new Tabernacle is remarkable, as Joseph Irwin's daughter, Linnie, was married to the Reverend Zachary Sweeney, who was pastor of the early Tabernacle when it was built. Other family members also were important in the life of the church, including J. Irwin Miller, who spearheaded the effort to use modern design in the new church's construction.

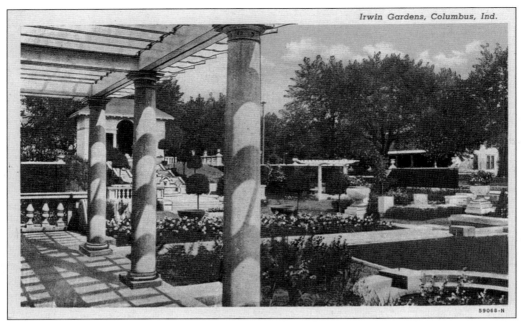

Irwin Gardens, Columbus, Ind.

59068-N

IRWIN GARDENS FROM THE BACK. This card shows the view from the back of the gardens towards the east end of the gardens and the front of the gardens along Fifth Street. The Italian sunken gardens were patterned after a small garden in Pompeii, Italy. Open seasonally to the public, the beautiful gardens continue to draw visitors from Columbus and beyond to this day. This card is unsent and *c.* 1930s–1940s.

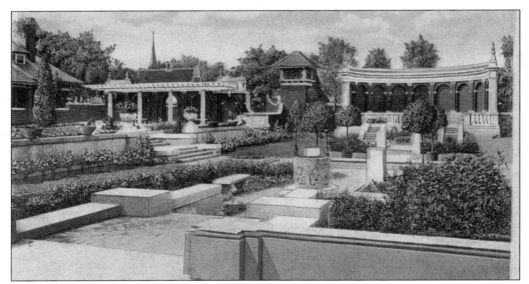

IRWIN GARDENS FROM FIFTH. Here the gardens are viewed from the entrance gate on Fifth Street. The steeple of the Presbyterian Church can be seen in the distance. A long message is written on the back of this 1940s card: "Sailing on the 13th from New York. We shall drop you a card from Queenstown. . . . These are pictures of one of the homes we have been entertained in. We spent a week here. It is a wonderful place. You would enjoy the flowers."

Seven

SCHOOL & LIBRARY VIEWS

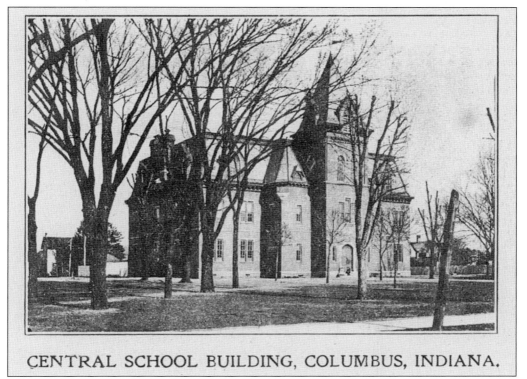

CENTRAL SCHOOL BUILDING, COLUMBUS, INDIANA.

CENTRAL SCHOOL BUILDING. This unsent card is labeled "Private Mailing Card" on the back, making it the oldest card included in this book, dating from 1898–1901. Shown is the original Central School—also known as Old Central—which was built in 1859 and replaced in 1904 by a newer school a block and a half away. This building stood between Sixth and Seventh Streets on Pearl.

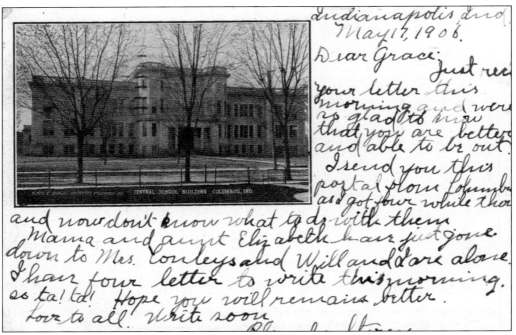

CENTRAL SCHOOL, 1906. The new Central School was built in 1904–1905 on Seventh Street between Mechanic and Pearl Streets. The cost was $76,701, and the school was thought to be very progressive with a gymnasium in the basement and an auditorium on the third floor. This card was sent in 1906 to Shelbyville, Indiana.

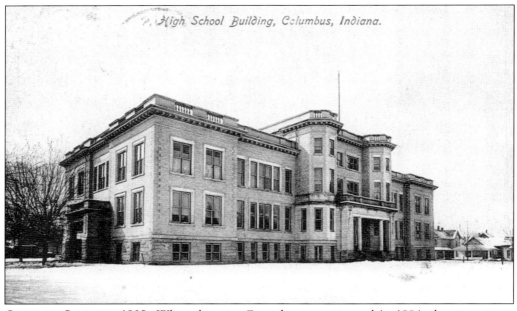

CENTRAL SCHOOL, 1909. When the new Central was constructed in 1904, the cornerstone from Old Central reading, "To our children, by the Citizens of Columbus, 1859" was included in the basement. This card was sent from Columbus to South Whitley, Indiana, in 1909.

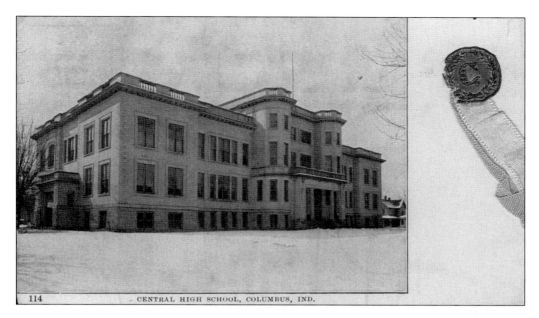

114 CENTRAL HIGH SCHOOL, COLUMBUS, IND.

CENTRAL SCHOOL RIBBONS. This real photo card includes a wax embossing on the front with blue and white ribbons. These have been the class colors of Columbus High School since 1917. The card includes a long message on the back from a teacher who sends frequent cards: "The busy season is here. This was the first week of our second semester and we start off in confusion . . . I haven't sent you more than two of these have I?"

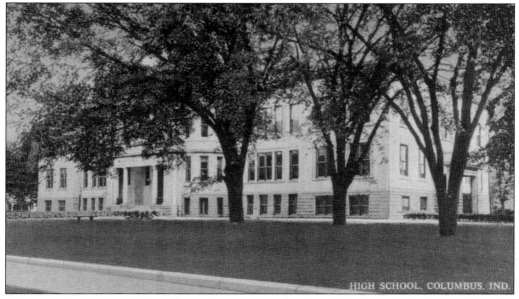

HIGH SCHOOL, COLUMBUS, IND.

CENTRAL SCHOOL, 1917. This card was postmarked in 1917 from Columbus to Lincoln, Kansas. Central remained a high school until 1956, when a new high school on the north side of Columbus was opened and Central became a junior high. The writer remarks, "I rec'd your picture a long time ago. Was sure tickled to get it but I'd rather see the original. I had my picture 'taken.'" Central is currently slated for demolition.

CENTRAL SCHOOL ENTRANCE. This real photo card shows the Pearl Street entrance to Central School. Above the door the inscription reads "The Hope of Our Country." The card is unsent, but there is a handwritten message on the back that reads, "Cols. High School 1918."

GYMNASIUM. The gymnasium that was located in the basement of Central quickly became inadequate for the school, and a new gymnasium was built in 1923 at Seventh and Pearl. The first basketball game was played there on November 9, 1923. Columbus High School beat Seymour High School 50-10. The swimming pool in the basement of this new building was one of the first indoor pools in the state.

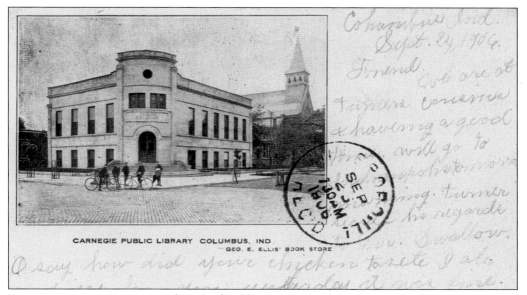

CARNEGIE PUBLIC LIBRARY COLUMBUS, IND
GEO. E. ELLIS' BOOK STORE

CARNEGIE LIBRARY, 1906. When the first library in Columbus opened in 1899 within city hall, it was immediately popular with the citizens of the town, and the need for a free-standing building was clear. In 1901, a letter was sent to American philanthropist Andrew Carnegie, who was known for financing libraries. On December 30, 1901, Mr. Carnegie replied that he would give Columbus $15,000 for the construction of a library.

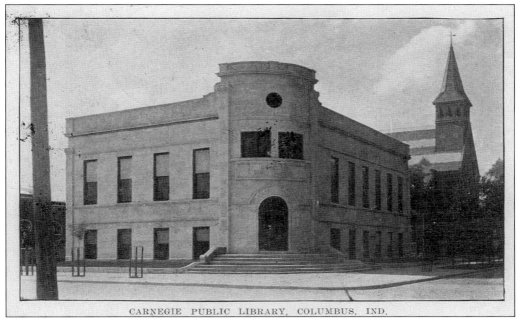

CARNEGIE PUBLIC LIBRARY, COLUMBUS, IND.

CARNEGIE LIBRARY, 1910. This building was dedicated on June 1, 1903, at the corner of Fifth and Mechanic. Part of the land had been donated by Joseph Irwin, who lived across the street. Just behind the library the Tabernacle Christian Church is visible. This card was sent from Ogilville, Indiana, to Spearfish, South Dakota, in 1910.

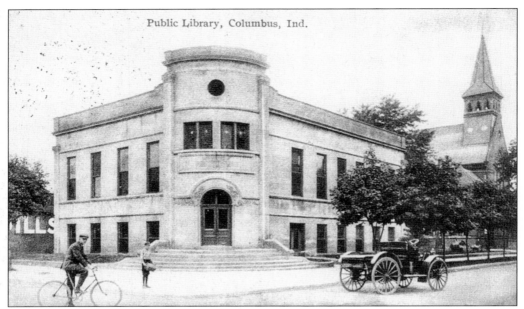

Public Library, Columbus, Ind.

PUBLIC LIBRARY, 1913. The library was initially known as the Carnegie Library and then the Columbus Library, before becoming the Bartholomew County Library in 1923. Two typical means of transportation of the time—bicycle and automobile—along with two boys in period dress are pictured in this card, which was sent in 1913 from Columbus to Louisville.

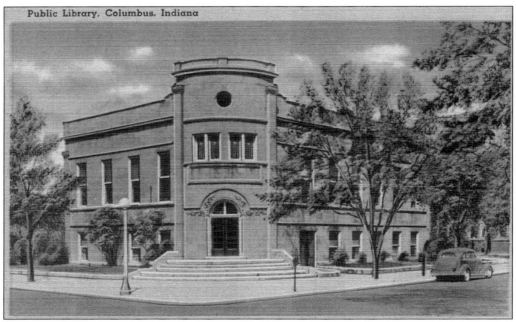

Public Library, Columbus, Indiana

PUBLIC LIBRARY. This library served until the 1960s, when it was replaced in the same spot by a modern library that was much larger and designed by renowned architect I. M. Pei. At that time, Lafayette Avenue between Fifth and Sixth (where the car in this view is parked) was permanently closed off to provide more space for the new library.

Eight
OUTDOOR VIEWS

RUSTIC SCENE. This card shows a rural setting outside Columbus, which was likely west of town, where the terrain is hillier than elsewhere in the county. The card was postmarked in 1917 in Flat Rock, Indiana, and sent to Anderson, Indiana.

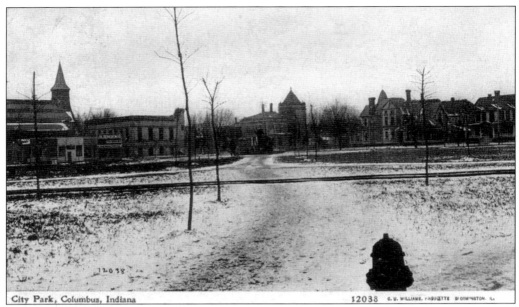

City Park, Columbus, Indiana 12038 C. U. WILLIAMS, FAYETTE BLOOMINGTON, ILL.

CITY PARK. This park was created where the Railroad Square had been located along Fifth Street. In this early view, the train tracks are still visible. Sent by a disgruntled friend in 1911 to Ypsilanti, Michigan, the sender writes, "When I was in the mood to write you I wanted to say something real mean so waited until I felt good. When you said how awfully hot you were there I wanted to say 'goody.'"

Central Park, Columbus, Ind.

CENTRAL PARK. This later card shows the park, also known as Central Park, with benches and a fountain. The library and Tabernacle are visible in the distance, but the vegetation has grown so much in this view that the tower of the Irwin home—visible in the previous card—is no longer evident. This card is unsent.

CITY PARK WITH CITY HALL. An even later image of the park, this card shows the view looking the other direction with city hall in the background. Eventually this area would become the home of the new Tabernacle, which became First Christian Church. This card was sent from Louisville to Indianapolis in 1930.

FOUNTAIN IN PARK. The park was also known as Commercial Park, and at one time there was a bandstand present there. On Friday nights, the Columbus Band often performed concerts in the park. Once this park was replaced with the church, the concerts moved to Donner Park. The card was sent to Seymour, Indiana, in 1912.

99

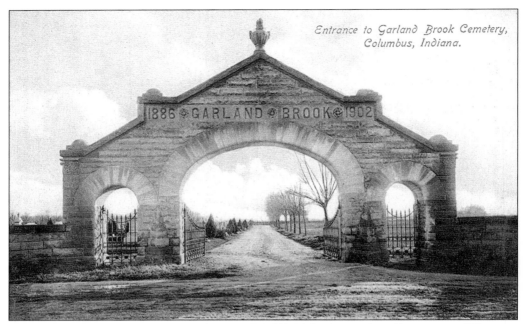

*Entrance to Garland Brook Cemetery,
Columbus, Indiana.*

GARLAND BROOK FROM TENTH. On June 25, 1886 *The Evening Republican* wrote, "The new cemetery, from which wheat has been harvested, was yesterday laid off and named, with the first burial today. It will be known as Garland Brook." This very early view of the cemetery from the entrance on Tenth Street shows only open land beyond the gate on the right. At the time, the cemetery was well outside the city limits of Columbus.

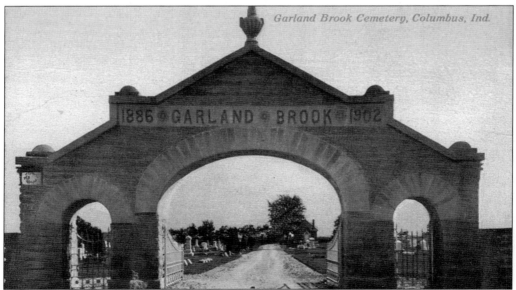

Garland Brook Cemetery, Columbus, Ind.

GARLAND BROOK, 1912. A later view from the same gate as the previous card shows many new gravestones. In February 1912, the sender writes, "I am all right. how are you. Our school won't be out until April. We haven't got the smallpox yet. I guess we won't get them." This gate is still visible along Tenth Street, although it is no longer used as an entrance to the cemetery.

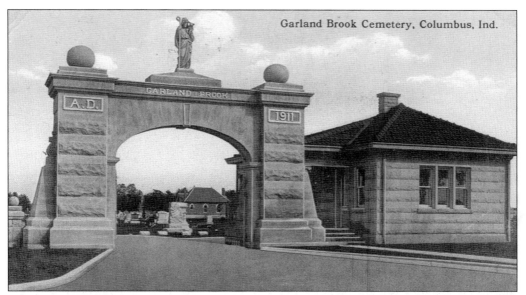

Garland Brook Cemetery, Columbus, Ind.

GARLAND BROOK MAIN ENTRANCE. This gate is still located along Gladstone Avenue and is the primary entrance into the cemetery, which is still in use today. This card was sent from Seymour, Indiana, to Indianapolis, but the year is not legible on the postmark. The sender writes, "Between the wind and the rain, I am driven to take refuge in Indianapolis so I am thinking I will appear on the scene on Sat. evening sometime."

OLD LANDMARK NEAR COLUMBUS, IND.
GEO E. ELLIS' BOOK STORE

This is not your Picture in the Creek

Joe & Dora

OLD LANDMARK. The location of this old log cabin is unknown. The card was sent September 22, 1906, from Columbus to Verona, Ohio. It was published by George Ellis, who owned a bookstore that was located at 515 Washington. George Cummins, who later opened Cummins Bookstore, served his apprenticeship under George Ellis.

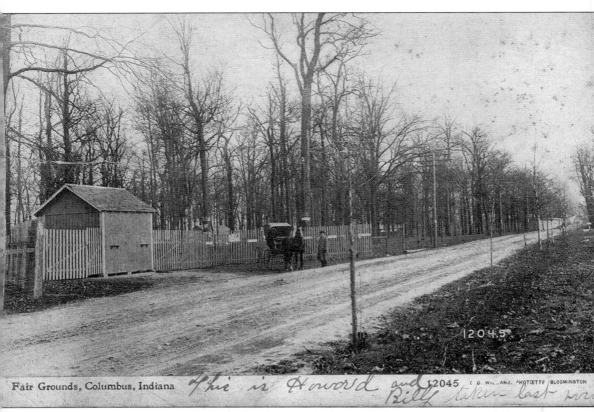

Fair Grounds, Columbus, Indiana *This is Howard and Billy taken last* 2045 C. O. WILLIAMS. PHOTOETTE BLOOMINGTON

FAIRGROUNDS. This view shows the fairgrounds that were located on Twenty-fifth Street in Columbus. Bartholomew County had held county fairs since the 1850s, initially in town where Central School would be built and then along the Flat Rock River between Tenth and Thirteenth Streets. The fairgrounds were moved to land that was then well outside of Columbus on Twenty-fifth Street in 1910. Other entertainment provided at the fair grounds included picnics, holiday celebrations, political rallies, auto and horse racing, and boxing matches. Fairground events were so popular that streetcars would run between downtown and the fairgrounds to bring people there. Although when constructed the fairgrounds were in a very rural setting, Columbus eventually expanded all around the fairgrounds. In 1958, the 4-H Fair moved to new grounds southwest of Columbus on S.R. 9. Gradually other events moved away as well, and the old fairgrounds fell into disrepair. In the 1980s, the land was purchased and developed into a shopping center.

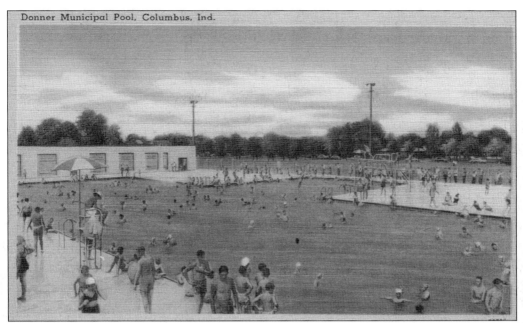

Donner Municipal Pool, Columbus, Ind.

DONNER POOL. These 1940s era unused linen cards show Donner Pool, which has been popular with the children of Columbus for over 50 years. Open daily in the summertime, the 50-meter pool still looks much like these early views, although a large water slide and a second pool for smaller children have been added. Today the pool is also used by the local swim club during the warm weather for practices and competitions. Donner Pool is located within the 32-acre Donner Park, at Twenty-second and Sycamore. The park is named for philanthropist Will Donner, who donated the land to the city in the 1920s. The park shelter house was built in 1924 and was used for many years by local musicians for summer concerts. In addition to the pool and shelter house, the park contains a large playground, a city cemetery, and ample green space.

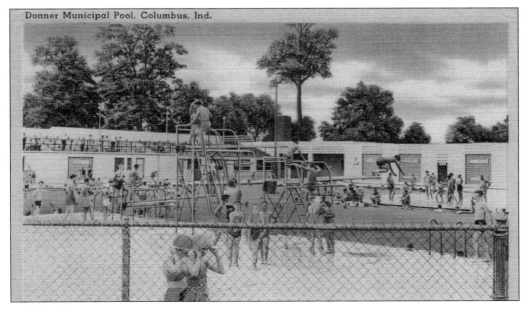

Donner Municipal Pool, Columbus, Ind.

COLUMBUS YOUTH CAMP

Entrance to camp and a view of the Big House

YOUTH CAMP. These unused cards show Columbus Youth Camp was founded in 1935 when Arvin co-founder Q. G. Noblitt provided 75 acres of land, along with money for construction. The Civilian Conservation Corps developed the lake, trails, and original six log cabins, and Youth Camp was dedicated in 1937. In 1958, the Lowell Engelking family gave another 40 acres to Youth Camp, and the camp reached its current size of 115 acres. The Big House seen in the top card was also known as the Hart Home, built in 1867 atop a hill west of Columbus. Mr. Noblitt purchased the home in 1932 and included it in his donation for the founding of the camp. Youth Camp today includes 11 cabins, 7 miles of trails, a lake, an outdoor theater, a shelter house, meeting and dining facilities, and 2 challenge courses. The camp is used by school groups, church groups, and others, for recreational and educational purposes.

Two of the nine modern cabins

COLUMBUS YOUTH CAMP

Nine
BRIDGES & RIVER SCENES

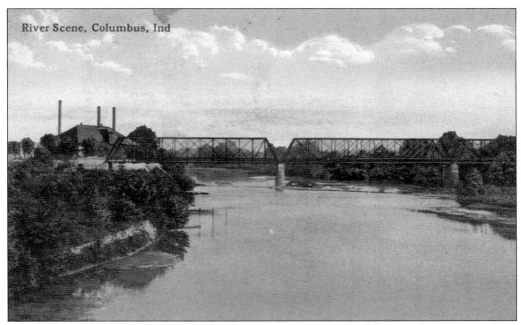

RIVER SCENE. This view is taken from the railroad bridge over White River looking toward the Second Street Bridge and the city waterworks. The card was postmarked March 1915, and sent from Columbus to Pence, Indiana. Prior to the construction of the first toll bridge in 1849, a ferryboat took passengers back and forth across the river.

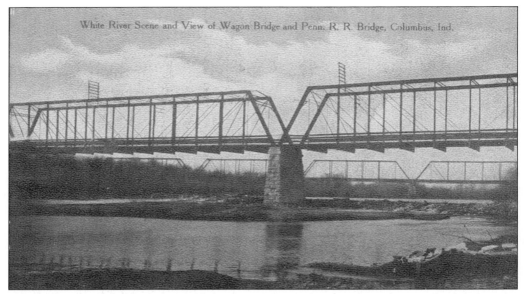

BRIDGES OVER WHITE RIVER. This 1910 card shows the view from the river bank below the waterworks. In the foreground is the Second Street Wagon Bridge, with the railroad bridge in the background. The railroad bridge still exists today, but a new bridge has replaced the wagon bridge to take cars out of town.

SECOND STREET BRIDGE. This is the view from the west side of the river looking east towards the waterworks and towards town. On September 9, 1909, newlyweds Will and Minnie sent the card to Indianapolis after eating at Zaharako's confectionary. The message on the back reads, "We are having a grand time. Minnie will not be home for a few days. We where (sic) married this afternoon and are at the Greek's now."

106

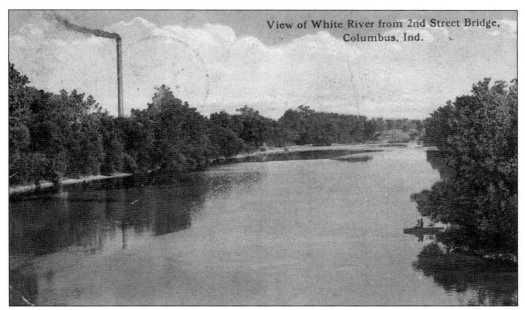

View of White River from 2nd Street Bridge, Columbus, Ind.

VIEW FROM SECOND STREET BRIDGE. Looking downriver from the wagon bridge, a small fishing boat is visible on the right, and a smokestack is visible in the distance. It is possible this smoke stack is from the Power House pictured on page 40. In 1920, the sender writes, "This is a little view of some of the beautiful scenery. We have here some swell fishing and camping places. You must come down this summer if it ever comes summer."

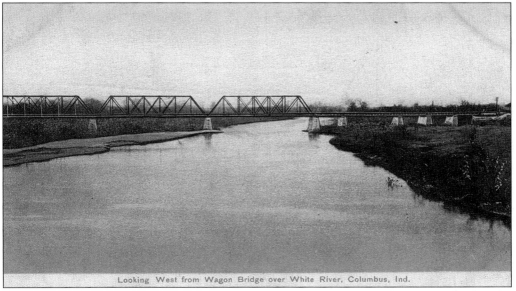

Looking West from Wagon Bridge over White River, Columbus, Ind.

WEST FROM SECOND STREET BRIDGE. Looking west or upriver from the wagon bridge, the Pennsylvania Railroad Bridge is again visible. The east side of the river by the railroad bridge was at the time known as Death Valley and was full of shacks and shanties that housed many of Columbus' less-fortunate citizens. This area frequently flooded after big rains. Today this area is part of Mill Race Park.

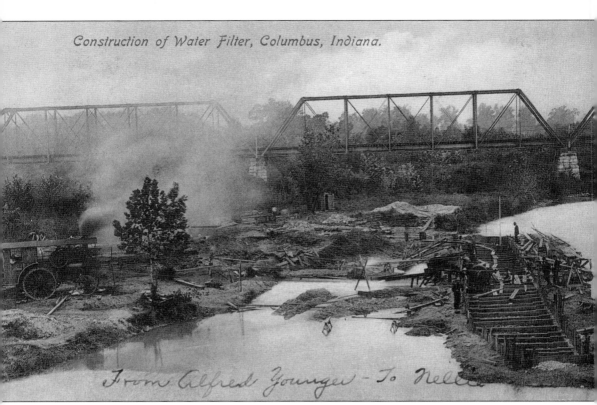

Construction of Water Filter, Columbus, Indiana.

From Alfred Younger - To Nell

CONSTRUCTION OF WATER FILTER. This real photo card shows the construction of the dam and water filter on the White River, which was used to power the city and supply Columbus with water. This gravel filter was reportedly constructed in 1903 and directed water into a cistern 10 feet in diameter and 35 feet deep. Adjacent to this site, the City Powerhouse and Waterworks was constructed. Water from the White River was pumped in for use in Columbus starting around 1870, although at times the water quality was so poor that it was unsafe for household use. According to *The Illustrated Columbus Indiana 1914–1915*, a newer water filtration system was built in 1913 using a rapid sand filter to remove more impurities in the three million gallons of water used daily. An on-site laboratory then tested the water for impurities. At the time of the plant's completion, the city boasted that it had one of the most modern water filtration systems in the state. This card carries no message, but was postmarked from Columbus to Medora, Indiana, July 31, 1908.

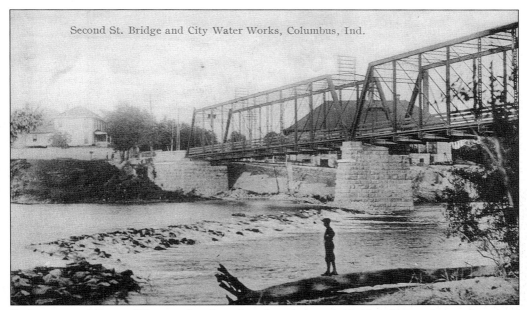

Second St. Bridge and City Water Works, Columbus, Ind.

BRIDGE AND WATER WORKS. Another view from below the bridge shows a home that stood at the east end of the bridge. This was demolished when a new bridge was constructed in the mid-1900s. Interestingly, the bridge that spans the river here today is called the Third Street Bridge, while a newer Second Street Bridge is south of here. This card was sent to Oak Park, Illinois, in 1913.

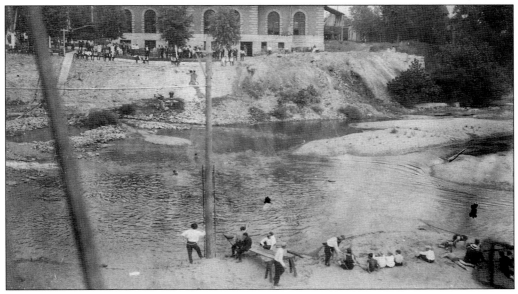

RIVER ACTIVITY. While this spot does attract the occasional fisherman today, the river below the waterworks appears to be a hotbed of activity in this *c.* 1910–1915 real photo card. Many boys and men appear to be enjoying their day at river's edge watching a few brave swimmers. This card is unsent.

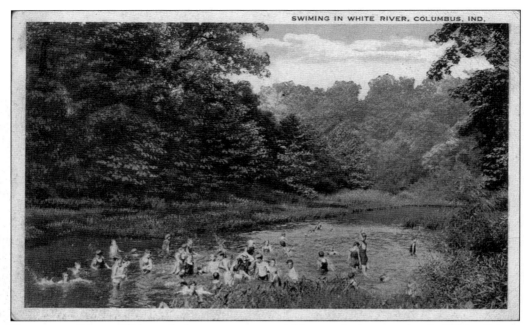

SWIMMING HOLE. This card shows numerous children enjoying a swim in White River. Although this card is not labeled, Columbus native William Marsh writes in his 1956 book about Columbus that the most popular White River swimming hole during his youth was just below where the Driftwood and Flatrock Rivers came together behind Mooney's Tannery near what is today Mill Race Park.

Old Wooden Bridge, White River, Columbus, Indiana 12044 E. U. WILLIAMS PHOTOETTE BLOOMINGTON, ILL.

EIGHTH STREET BRIDGE. This covered bridge crossed the river at the end of Eighth Street. The buildings visible on the riverbanks are part of the Crump Brickworks. Although the card says White River, the Eighth Street Bridge actually crossed the Flatrock River just slightly upriver from where it joins the Driftwood and becomes the White River.

Lowell Bridge, Columbus, Ind.

LOWELL BRIDGE. Long ago this covered bridge spanned the Driftwood River northwest of Columbus. When the bridge was removed is unclear, but the remains of the road that led to the old bridge can still be seen today just before crossing the modern bridge on Lowell Road. Today a quiet public access area for boating and fishing exists below Lowell Bridge, but over a century ago, a bustling town could be found here. Between 1830 and 1880, the town of Lowell Mills flourished in this area along the river. The town included two grist mills, a woolen mill, a cooperage, a shoemaker's shop, a distillery, a saw mill, an inn, and a general store. After the mills closed in the late 1800s, the town was abandoned. Today all traces of the town are gone, and the area around the bridge includes farmland and a few homes. This card was sent to Indianapolis from Columbus in November 1910 without any message.

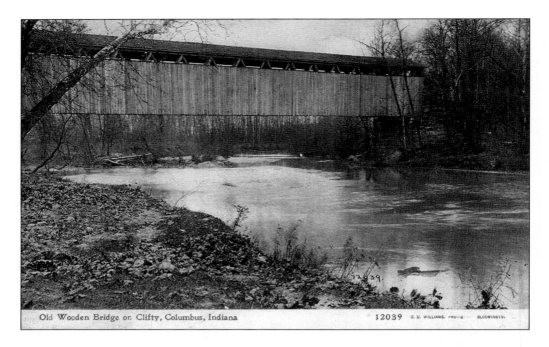

Old Wooden Bridge or Clifty, Columbus, Indiana 12039 C. U. WILLIAMS, PHOTO BLOOMINGTO.

CLIFTY BRIDGE. These cards show real photo views of the covered wooden bridge that crossed Clifty Creek south of Columbus. The creek was a popular place for local kids to play below the bridge. When the area within Columbus known as Death Valley was cleaned up and transformed into Mill Race Park, this covered bridge was moved to the park to showcase it for all of Columbus. Unfortunately, the bridge was destroyed by arson in the 1980s. It was subsequently replaced in the park by another covered bridge from elsewhere in Indiana that still stands today. Both of these cards are unused, with the top *c.* 1920s and the bottom *c.*1950s.

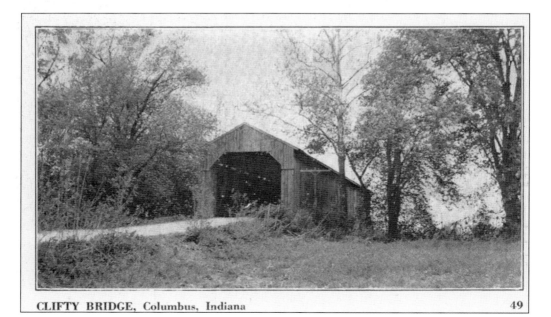

CLIFTY BRIDGE, Columbus, Indiana 49

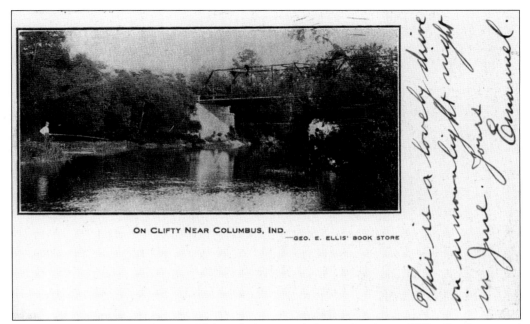

ON CLIFTY NEAR COLUMBUS, IND.
—GEO. E. ELLIS' BOOK STORE

This is a lovely drive on a moonlight night in June. Yours Emanuel.

RAILROAD BRIDGE ON CLIFTY. This real photo card shows also shows Clifty Creek spanned by a railroad bridge with a man fishing at the side of the creek. This very early undivided back card was send from Columbus to St. Louis, Missouri, in 1906. It is not known where this bridge was located. The message reads, "This is a lovely drive on a moonlight night in June."

Fatal Ford, Columbus, Ind.

FATAL FORD. According to longtime residents of Columbus, Fatal Ford was one of two fords within Columbus and was located on Clifty Creek east of town at the end of McKinley Street. After heavy rains, the water would be much higher and cars frequently would get stuck and need to be pulled from the water. The other ford was located where Rocky Ford Road crosses Haw Creek. This card was postmarked August 1909.

113

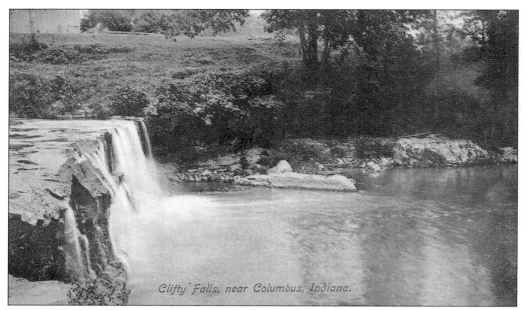

Clifty Falls, near Columbus, Indiana.

CLIFTY FALLS. This real photo card shows what was called Clifty Falls located in eastern Bartholomew County. At some point during the 20th century, the falls became known as Anderson Falls, named for David Anderson, who had operated a grist mill nearby in the late 1800s. Presumably the change was made because Clifty Falls State Park in southern Indiana has a much larger falls of that name. This card was sent to Connersville, Indiana, in June 1908.

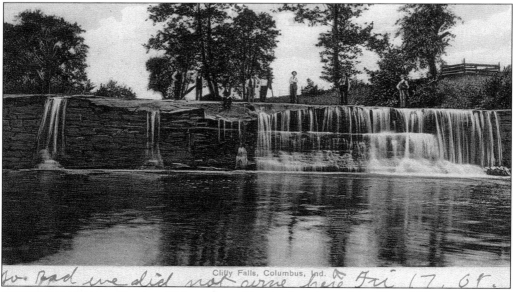

Clifty Falls, Columbus, Ind.

CLIFTY FALLS FROM BELOW. This card provides another view of the falls, which are more than 100 feet wide and more than 15 feet high. The surrounding land was purchased by the Nature Conservancy in 1977 and given to the county parks department in 1981, with the agreement it would be maintained as a nature preserve. In July 1908 this card was sent from Columbus to Kokomo, Indiana.

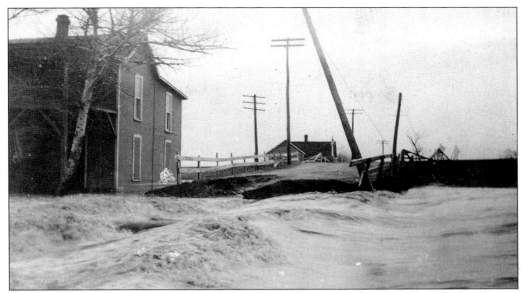

FLOOD OF 1913, RAILROAD CROSSING. This real photo card is unsent but has a handwritten description on the back, which reads, "At railroad crossing west of Second St. Bridge." Because this scene does not appear to show the railroad bridge, it likely shows where the railroad tracks crossed the road west of the river before coming to the bridge. This is an area that still floods today after heavy rains.

FLOOD OF 1913, INTERURBAN TRACKS. On the back of this unsent card are the words, "Interurban Bridge North of Columbus." Where this bridge was located is unclear, but it must have spanned the Flatrock River to come into town from the north. The utility poles next to the tracks confirm these were tracks used for the electric interurban trains.

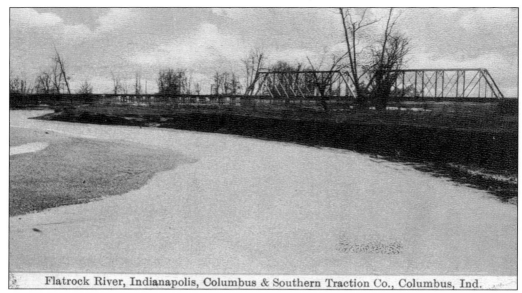

Flatrock River, Indianapolis, Columbus & Southern Traction Co., Columbus, Ind.

RAILROAD BRIDGE OVER FLATROCK, 1911. This card was sent from Shelbyville, Indiana, to Kokomo, Indiana, in 1911. Where the bridge was located is unclear, although early maps of Columbus show a railroad bridge crossing Flatrock several blocks north of the Eight Street Bridge. No utility poles are visible in the view, suggesting steam trains used these tracks. At the time of this view, the tracks would have been well-traveled, as 23 steam trains a day were reported to pass through Columbus by 1914.

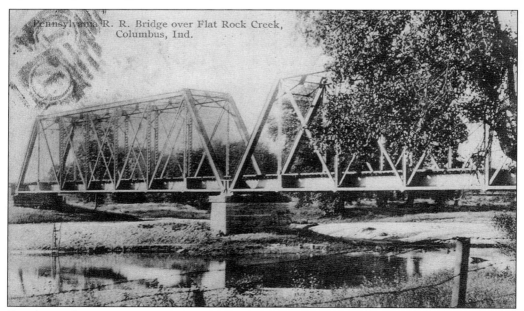

Pennsylvania R. R. Bridge over Flat Rock Creek, Columbus, Ind.

RAILROAD BRIDGE OVER FLATROCK, 1914. The angle makes it impossible to know if this is a different railroad bridge from a different railroad company. The card was sent to the writer's cousin in the military and reads, "I rec'd your postal. Your photo is just fine. You certainly look grand in your uniform. Sorry to hear you are going to the Philippine Islands. Hope you will like it."

BOATING ON FLATROCK. This colorful early card from *c.* 1910 shows two women in a small boat on a quiet Flatrock River. It was postmarked from Seymour, Indiana, with the sender noting, "this place is about 18 miles north of here." Today the Driftwood River is somewhat more accessible and is used more commonly than the Flatrock for recreational boating trips by canoe.

SUSPENSION BRIDGE. Postmarked in September 1906 from Columbus to Cincinnati, this undivided back card included the sender's laments that her friend did not join her on a trip. The card shows a rickety suspension bridge, the location of which is unknown.

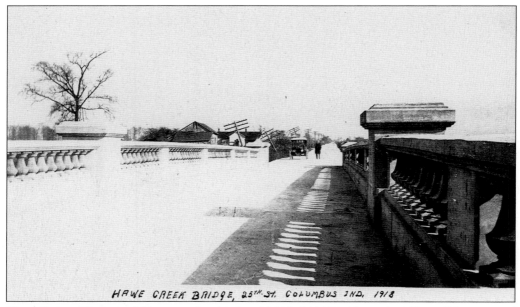

HAW CREEK BRIDGE. This unsent card is hand-labeled 1918 with a misspelling of the name of the creek. This bridge crossed Haw Creek on Twenty-fifth Street, when this was far from the rest of Columbus. A few buildings are visible in the distance, suggesting that this is looking from the bridge back towards town. It appears the utility poles are just being erected.

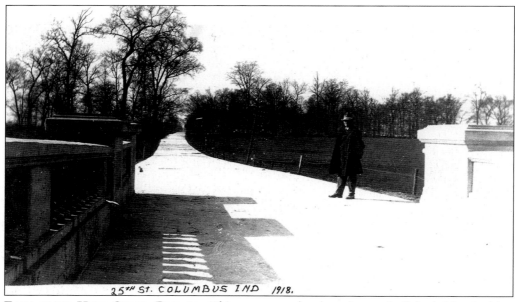

EAST FROM HAW CREEK BRIDGE. This appears to be the other end of the bridge looking down a narrow and lonely stretch of Twenty-fifth Street before there is any development east of Haw Creek. Today Haw Creek crosses Twenty-fifth Street at the intersection of Twenty-fifth and National Road, which is one of the busiest intersections in town. This unsent card is also labeled 1918.

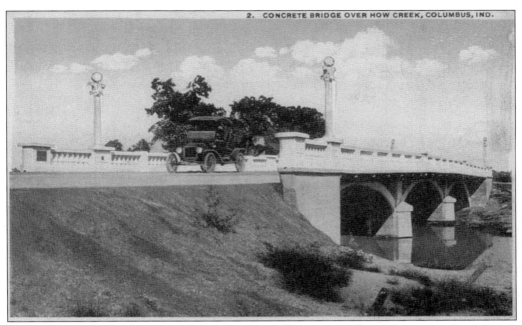

2. CONCRETE BRIDGE OVER HOW CREEK, COLUMBUS, IND.

HAW CREEK BRIDGE, 1922. This card carries a different misspelling of Haw Creek. Although the road is not labeled, it appears to be the Twenty-fifth Street Bridge after the addition of tall light poles. This card is postmarked 1922. The sender writes, "We are having a great time. The children are certainly enjoying it. My uncle is almost 97 yrs old and his son 70 yrs old. So much good country eats."

View North from Haw Creek Bridge, Columbus, Ind.

NORTH FROM HAW CREEK BRIDGE. This card was sent in 1908 to Mt. Vernon, Ohio, from Columbus. The view appears to show a bench at the edge of Haw Creek. Today a walking and biking path known as the People Trail travels along Haw Creek right at this point near the Twenty-fifth Street Bridge. Although it is right in town, the area remains picturesque today.

119

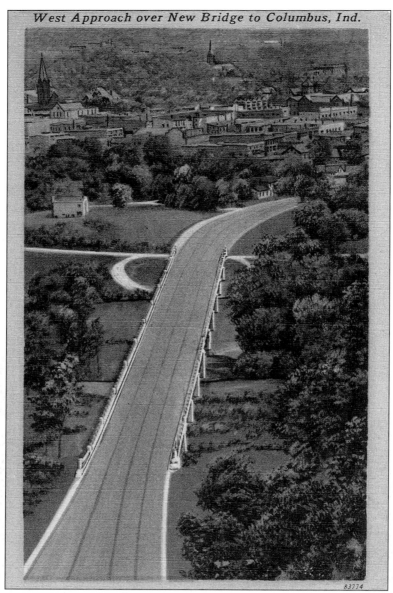

West Approach over New Bridge to Columbus, Ind.

83774

NEW BRIDGE. This 1953 linen card shows the view of the new Third Street Bridge heading into town. The waterworks is obscured behind the trees, but the skyline of Columbus reveals several familiar landmarks. The steeples of St. Bartholomew and First Presbyterian are easily located, and the Baptist Church can also be seen near the Presbyterian church. The tower of old city hall and the architectural detail of the beautiful windows of the Irwin Block are visible. The building that can be seen just above city hall appears to be Central School. Due to the angle of the view into town, the most recognizable building of the Columbus skyline—the Bartholomew County Court House—is not present. Today this bridge has been replaced by two bridges. A modern suspension bridge goes one-way east into Columbus, and another bridge (located where this bridge was) runs one-way west out of town.

Ten
MODERN
ARCHITECTURE

COLUMBUS CITY HALL. The Columbus City Hall was competed in 1981 and designed by Edward Charles Bassett. The building is a right triangle, and the front of the building is the long side facing the corner of Washington and Second Streets looking towards the court house. The impressive elements of the building visible from the front include the two 35-foot-long cantilevers that extend out over the top of the steps, the open courtyard just beyond, and the semicircular glass curtain wall.

ARCHITECTURAL TOUR. Columbus has become a destination for people from around the world, and the visitors center reports that more than 150,000 visitors come to Columbus each year. Many of them come to experience Columbus' storied collection of modern architecture, either by taking a self-guided walking or driving tour or by enjoying one of the daily bus tours conducted by a trained volunteer.

CLEO ROGERS MEMORIAL LIBRARY. Standing across the street from First Christian Church on the same spot the old Columbus Library once inhabited is the new library, designed in 1969 by I. M. Pei. Other significant designs from I. M. Pei include the glass pyramids outside the Louvre in Paris and the Rock and Roll Hall of Fame in Cleveland.

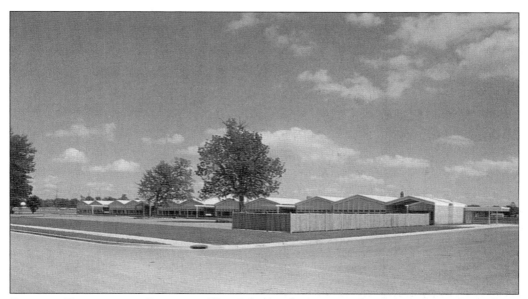

SCHMITT ELEMENTARY SCHOOL. Lillian Schmitt Elementary School opened in 1957 and was the first school constructed with funds from the Cummins Foundation used for architecture fees. The back of this 1960s card describes this "Ultra-modern Elementary School designed by Harry Weese, world famous architect." Weese designed the building with a low roofline, designed to be non-threatening to children, and with doors to the outside from every classroom.

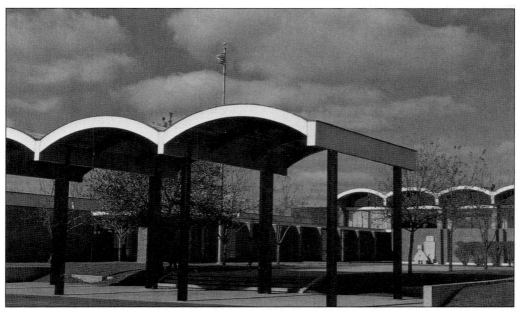

PARKSIDE ELEMENTARY SCHOOL. During the 1950s, the need for new schools to educate baby boom babies became evident. The successful construction of Schmitt proved that the architecture program in Columbus would work for schools, and many others were constructed in the same manner. Parkside Elementary School was built on the north side of town in 1962, designed by Norman Fletcher of The Architects Collaborative.

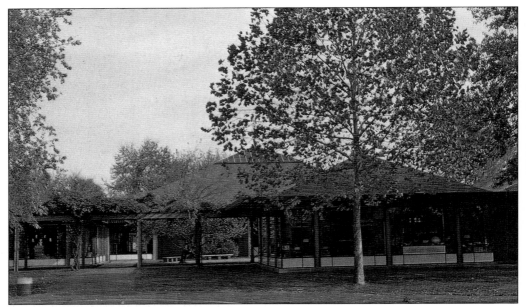

McDowell Adult Education Center. Originally Mabel McDowell Elementary School, this building was designed by John Carl Warnecke and completed in 1960. Currently used for continuing education and adult education programs, the school is a collection of pavilions standing in a park–like setting near Garland Brook Cemetery in east Columbus.

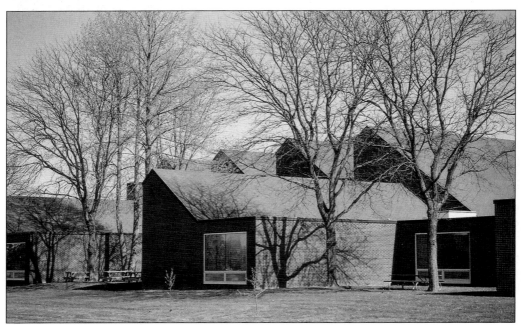

W. D. Richards Elementary School. Richards Elementary School was designed by Edward Larrabee Barnes and opened in 1965 across the street from Harry Weese's First Baptist Church.

NORTH CHRISTIAN EXTERIOR. In 1961, Eero Saarinen, son of the designer of First Christian Church, finished his design for North Christian, which he hoped would be a "prototype for Twentieth Century Christianity." Perhaps best known for designing the Gateway Arch in St. Louis, Eero Saarinen died before construction could begin, and this was his last design. The church is a hexagon with a 192-foot, leaded-copper spire. It was dedicated in 1964.

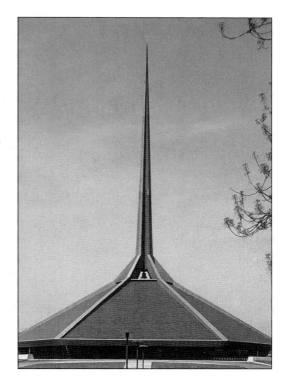

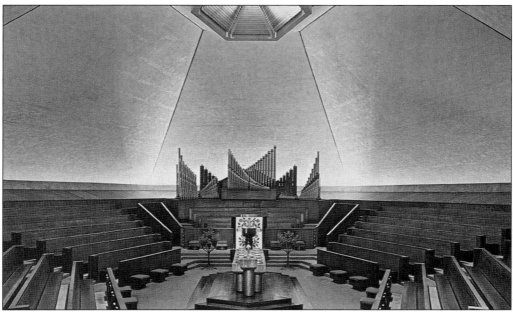

NORTH CHRISTIAN INTERIOR. The communion table sits at the center of the sanctuary, which is also the very center of the hexagon. This represents the fact that communion is felt to be central to the worship of the church. Designed to be reminiscent of a family sitting around the dinner table at home, the church pews completely encircle the communion table.

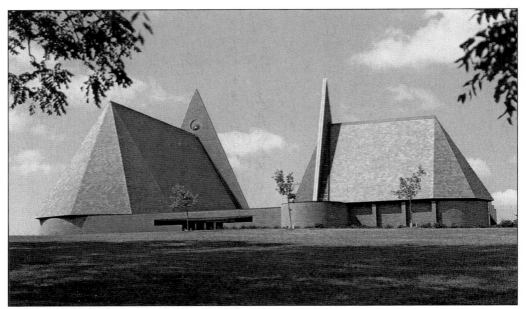

FIRST BAPTIST CHURCH. In 1965, the very unique Fairlawn Baptist Church became the third church designed by a renowned architect, after First Christian and North Christian. The church was built in a neighborhood on the northeastern side of Columbus, and Harry Weese was the architect. By this time, Weese had already designed several other buildings in town and was well-known in Columbus. Later the name was changed to First Baptist Church after the original church downtown was razed.

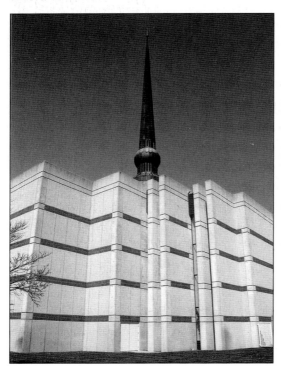

ST. PETER'S LUTHERAN. Gunnar Birkerts designed the new St. Peter's Lutheran Church, which was constructed in 1988 right next to the old German Lutheran Church and across the street from Lincoln Elementary School, also designed by Birkerts.

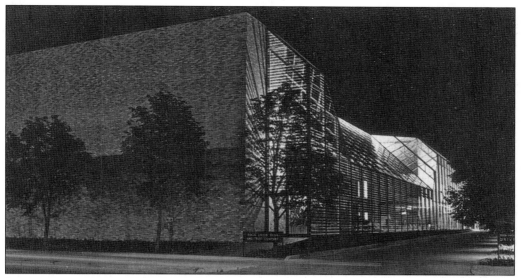

IRWIN UNION BANK. After First Christian Church, the construction of Irwin Union Bank in 1954 was the next experiment with modern architecture in Columbus. J. Irwin Miller, who was so instrumental in setting the path for First Christian Church's innovative design, was president of the bank at the time and requested another very contemporary plan. This card shows the addition to the building by Kevin Roche, John Dinkeloo and Associates in 1973.

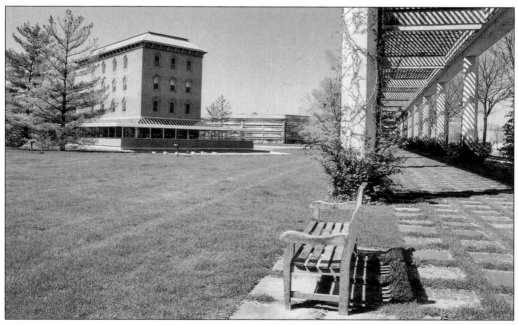

CUMMINS CORPORATE OFFICE BUIDLING. Also designed by Kevin Roche, John Dinkeloo and Associates, the new world headquarters for Cummins was built in 1983. The building is made of concrete and glass and is over 200,000 square feet. It occupies three square blocks where the Pennsylvania Railroad Station was once located, and the new building encircles and incorporates the old Cerealine Mill, one of Columbus' earliest manufacturing plants from the 19th century.

BIBLIOGRAPHY AND POSTCARD SOURCES

Bartholomew County Historical Society postcard collection.

Columbus: 125 Years. Columbus, Indiana: The Republic, 1997.

David Yount postcard collection.

Fish, Henry. *Illustrated Columbus, Indiana: 1914-15*. Columbus, Indiana. 1915.

Jones, Susanna, Ed. *Bartholomew County Columbus, Indiana Sesquicentennial*.
The Avery Press, Inc. 1971.

Korab, Balthazar. *Columbus, Indiana: An American Landmark*. Kalamazoo,
Michigan: Documan Press, 1989.

Marsh, William. *I Discover Columbus*. Oklahoma City: Semco Color Press, 1956.

Reed, Robert. *Central Indiana Interurban*. Charleston: Arcadia Publishing, 2004.

Souvenir Program: Grand Army of the Republic, Columbus, Ind. 1898. Reproduction.
Evansville, Indiana: Unigraphic, 1980.

www.columbus.in.us

www.columbusyouthcamp.com

www.historiccolumbusindiana.org

www.indianahistory.org

www.trolleystop.com